MASTERWORKS FROM

The Louise Reinhardt Smith Collection

MASTERWORKS FROM

The Louise Reinhardt Smith Collection

THE MUSEUM OF MODERN ART, NEW YORK

PUBLISHED IN CONJUNCTION WITH THE EXHIBITION *MASTERWORKS FROM THE LOUISE REINHARDT SMITH COLLECTION*
AT THE MUSEUM OF MODERN ART, NEW YORK, MAY 4—AUGUST 22, 1995
ORGANIZED BY KIRK VARNEDOE, CHIEF CURATOR, DEPARTMENT OF PAINTING AND SCULPTURE

THIS EXHIBITION AND ITS ACCOMPANYING PUBLICATION ARE MADE POSSIBLE BY A GENEROUS GRANT FROM
DOROTHY AND LEWIS CULLMAN IN HONOR OF THEIR FRIENDSHIP WITH LOUISE REINHARDT SMITH.

PRODUCED BY THE DEPARTMENT OF PUBLICATIONS
THE MUSEUM OF MODERN ART, NEW YORK
OSA BROWN, DIRECTOR OF PUBLICATIONS
EDITED BY MARY CHRISTIAN
DESIGNED BY JODY HANSON AND JEAN GARRETT
PRODUCTION BY AMANDA W. FREYMANN, ASSISTED BY CYNTHIA EHRHARDT
PRINTED AND BOUND BY IMPRIMERIE JEAN GENOUD, LAUSANNE, SWITZERLAND

LIBRARY OF CONGRESS CATALOG CARD NUMBER 95-075111

ISBN 0-87070-148-7 (THE MUSEUM OF MODERN ART, CLOTHBOUND)
ISBN 0-8109-6147-4 (HARRY N. ABRAMS, INC., CLOTHBOUND)
ISBN 0-87070-149-5 (THE MUSEUM OF MODERN ART, PAPERBOUND)
PUBLISHED BY THE MUSEUM OF MODERN ART, 11 WEST 53 STREET, NEW YORK, NEW YORK 10019

CLOTHBOUND EDITION DISTRIBUTED IN THE UNITED STATES AND CANADA
BY HARRY N. ABRAMS, INC., NEW YORK, A TIMES MIRROR COMPANY

PRINTED IN SWITZERLAND

PHOTOGRAPH CREDITS:
DAVID ALLISON, PAGE 79; KATE KELLER, PAGE 29; THE MUSEUM OF MODERN ART, PAGES 12, 15, 71;
MALI OLATUNJI, PAGES 27, 73; MALCOLM VARON, PAGES 21, 23, 25, 31, 33, 35, 37,
39, 41, 43, 45, 47, 49, 51, 53, 55, 57, 59, 61, 63, 65, 67, 69, 75, 77, 81, 83.

FRONT COVER:
VASILY KANDINSKY. *PICTURE WITH AN ARCHER (THE BOWMAN)*, 1909
OIL ON CANVAS, 69⅝ X 57⅞ IN. (177 X 147 CM)
THE MUSEUM OF MODERN ART, NEW YORK
FRACTIONAL GIFT OF LOUISE REINHARDT SMITH.

CONTENTS

FOREWORD

Among the great privileges of directing an institution like The Museum of Modern Art is acquaintance, and often friendship, with some of the extraordinary individuals responsible for its preeminence—whether trustees, staff members, or members of its extended family of supporters. Louise Smith is certainly one of these individuals, and happily for me, I have enjoyed her friendship for more than twenty years. Like all her friends, I am delighted that this celebration of Louise as a collector and donor also allows us to celebrate her as a remarkable person whom we warmly cherish.

Louise has been a trustee of the Museum for three decades. The attributes that make her exemplary in this role—generosity, wisdom, dedication—are complemented by special qualities of candid wit, insight, kindness, and enthusiasm. The additional qualities of her eye and judgment as a connoisseur and collector of modern art are so evident in this exhibition and publication that they need no elaboration here. I will note, however, that I have always been impressed and moved by the depth of feeling Louise has for the works of art with which she has surrounded herself. Having long ago passed her rigorous testing of time with them, these works are now integral parts of her life. Familiarity has not dimmed the excitement she found in them initially, and the continuing pleasure and stimulation she draws from them are refreshing testimony to the power of art to enrich our lives. Given this bond with her pictures, her always generous response when asked to lend to Museum exhibitions is all the more appreciated. A small compensation, I suspect, is that she enjoys testing her eye on pictures lent to her in temporary substitution. Few of these pass the test, since few are likely to be as good as the works they replace.

Max Beerbohm suggested that mankind was naturally divided into two categories: hosts and guests. Louise Smith is decidedly among the former. Her hospitality goes beyond delightful evenings with a skillful mix of congenial guests. It extends, whenever we ask the favor, to showing her collection to visitors from other places, here and abroad, welcoming with equal grace a minister of culture or a fledgling curator. As her long and active involvement with the Museum's International Council indicates, Louise takes special pleasure in acquaintances and friendships with artists, curators, and collectors around the world, prizing art's ability to transcend national boundaries.

In sum, there are a great many qualities for which her friends value and love Louise Smith. Above all, we admire her unfailing zest for life. With her quick intelligence, humor, and courageous will, she refuses to cede much ground to the infirmities of age. She maintains her interests not only in art but also in her writing (which once earned her the distinguished O. Henry Prize for a short story), and she continues to form new friendships while thoughtfully tending old ones. She is an inspiration—and marvelous company.

Richard E. Oldenburg
Director Emeritus

PREFACE

Newcomers to my home invariably ask the same questions: "What made you decide to collect?" "Which was the first painting you acquired?" What I actually collected were people. I was lucky to begin at the top and remain there, thanks to René d'Harnoncourt, who introduced me to James Thrall Soby and Alfred H. Barr, Jr., who introduced me to The Museum of Modern Art. I shall always cherish the endless list of inspired and inspiring people whom I know at the Museum.

I first met René d'Harnoncourt when Dwight Morrow, then our Ambassador to Mexico, commissioned him to organize the first exhibition of Mexican art in the United States. While René was teaching at Sarah Lawrence College, he and his wife often spent weekends visiting my husband and me on our farm in the foothills of the Berkshires. There I really did collect. I collected cows. We had about sixty advance-registered Guernseys. Our cows were beautiful in color, shape, and size. Our herdsman was immensely proud of them and so were we, although they proved to be an expensive pursuit—considerably more extravagant than collecting paintings.

My interest in "modern old masters" began as occupational therapy after my husband's death, when I desperately needed to divert my thoughts. Much as I enjoyed weekends in the country, I was always happy to return to the city, where I could enjoy all the museums and galleries. Whenever I visited The Metropolitan Museum of Art's Nineteenth-Century Wing, I found it both amusing and disturbing to see so many visitors at major shows who were more engrossed in reading the paper flyers that accompanied every picture than in looking at the art.

I never had any formal education in art, so my friendships with René, Alfred, and Jim were a godsend. I already knew how to look, but they taught me how to see. I understood that dealers were disinclined to show their really important paintings to new collectors. After I acquired a few significant pictures, they became quite willing to show me the works they considered top-drawer. Whenever I was fortunate enough to discover a painting I really loved, I had the wit to ask that it be sent to my home so I could live with it a few days until I was sure that I belonged with the painting and the painting belonged with me.

I never sought anyone's help in my quest, but I invariably asked Alfred and Jim to come for a drink and look at the painting I had fallen in love with. The only thing I asked of them was to tell me if the picture I wanted was something that The Museum of Modern Art would welcome as a promised gift.

As soon as I saw *Woman Dressing Her Hair*, which I consider Picasso's toughest painting, at the 1957 Picasso exhibition at the Museum, I knew I had to have it. When Alfred and Jim came to see it in my apartment they were overcome with joy that I would buy it and eventually give it to the Museum. "Most of my friends are sure to hate it," I said to Jim. "You tell them that the ugly can be beautiful—the merely pretty never," he replied.

A few months later, when I was skiing at my beloved Alta, Utah, I returned to the lodge for lunch and the telephone at the front desk was ringing. It was Alfred calling me. "Will you do me a great favor?" he asked. "Will you give us Picasso's *Pregnant Woman* in place of *The Glass of Absinthe?*" "But Alfred," I objected, "the Museum has to have *The Glass of Absinthe*. It's the first Cubist sculpture Picasso ever made. The Museum must have both and I am sure you won't mind my giving you both." "Are you certain?" he asked." "I wouldn't suggest it unless I meant it," I replied. "May I call you in the morning to make certain you haven't changed your mind?" "Please don't call me," I begged, "the snow is absolutely perfect and I want to get on the slopes as early as possible." He asked nervously if I would send a telegram to confirm my promise. So I dispatched a wire saying "Seldom in the history of modern art has a glass of absinthe led so directly to a pregnant woman."

What pleases me most about my collection is that there is nothing in it that does not live happily with everything else. If one is sure of what one likes, one can be equally sure that it will all belong together. In every period there are always a few great painters. I was fortunate to enjoy an era when modern old masters were available at affordable prices. I was in the right place at the right time.

Louise Reinhardt Smith

PREFACE

When I first arrived at The Museum of Modern Art in 1966 I was intrigued by the frequent in-house use of the term "Museum family." Happily, it did not take me long to find out just what that meant and how well it expressed a certain spirit that could be shared by people from the trustees down through the staff, by the carpenters and guards as much as by the curators. As in any extended family, some members are closer than others. I don't know anyone I have been closer to over the last quarter of a century than Louise Smith. She could pass, at the very least, for my favorite aunt.

I suppose the first thing that made me feel kinship to Louise was a sense of shared pleasure and understanding as we looked at paintings. Louise was less a "collector" than an impassioned explorer of art in general, though she quite naturally had a special affection for the unique brood of masterpieces she had gathered around her at home. The passion with which she experienced art carried over into her involvement with people, and she proved to be a conversationalist of great wit and frankness as well as sympathy. Not the least of our shared interests was, by the way, skiing. Although I was "done in," so to say, by that sport early in my career at the Museum, I continue to love it. And nothing pleases me more than the image of Louise on the slopes—where she could be found, in fact, until quite recently.

Louise is usually at her most radiant in her beautiful apartment, designed by architect and good friend Wilder Green, formerly Director of Exhibitions at the Museum. It is especially at home, surrounded by her friends and her art, where she generates and communicates to others an extraordinary sense of well-being. When fortunate enough to be included in one of her intimate "non-dinner" parties, as she loves to call them, those relaxed evenings of Texas hospitality, I rarely fail to enjoy the company of congenial spirits who share her dedication to art, literature, and above all, good conversation.

In social situations Louise can do gracefully what others might consider impossible. Through deft orchestration and a wry sense of humor she is able to bring together people who might otherwise not happily—or even willingly—socialize. I remember one inspired "non-dinner" party to which Louise had invited Jacqueline Picasso and my late French friend and colleague, Dominique Bozo. Jacqueline, unlike Picasso's previous wife Olga, was an ardent defender and passionate *amateur* of her husband's work (and also a remarkably generous donor of it to the Museum). She had envisioned a museum for Picasso's art ever since his death (if not before), at a time when the possibility of such a museum had not yet entered the mind of anyone in the government.

At the time of this dinner, Dominique—by then the museum's director designate—had not yet been able to advance very far with what was to become Paris's Musée Picasso, and Jacqueline had grown weary and impatient with his seeming inability to navigate the political and bureaucratic waters and hurdle the preposterous labor union barriers that delayed its realization. Yet after we had finished an hour of drinks and gathered around Louise's modest-sized dinner table, Jacqueline seemed transformed—and embraced Dominique in forgiveness and friendship. By the time the two parted, they had formed a team, had become true collaborators—which certainly helped foster the brilliant results that we see now in the Hôtel Salé. Louise had immediately intuited where the crux of the conflict lay, and must have also foreseen the nature of the reconciliation, which her own personal magic did much to bring about. Indeed, Louise had somehow put a charm on Jacqueline and Dominique. As she has on me, and mine.

William Rubin
Director Emeritus
Department of Painting and Sculpture

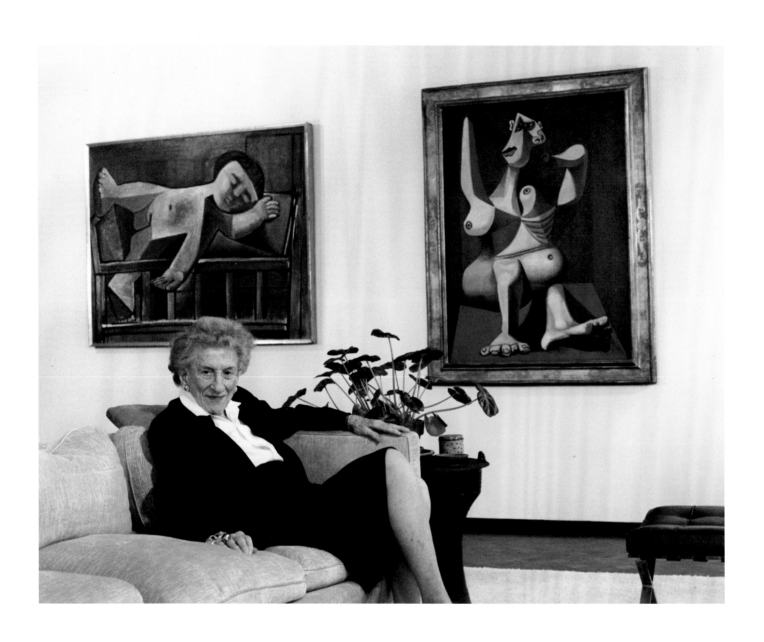

INTRODUCTION

When I hear the word "reflect" I reach for my suspicions. Every time we are told that a work of art reflects its time, or that a collection reflects the collector, we are almost certainly being offered an invitation to oversimplify. Art betrays its epoch and objects bespeak their owners in ways that do not show in shiny surface mimesis, but require compound lenses to study and understand. This is doubly so in the case of a collector such as Louise Smith, who has chosen not to focus on a single artist or movement, but to surround herself with paintings, sculptures, drawings, and prints of widely different moods and characters, from intimate portraits to monumental expressionist landscapes.

Still, given the happy task of surveying the walls of Mrs. Smith's apartment, one can hardly resist the intuition that there are significant rapports between the pictures and the person in that welcoming space. These objects were, after all, chosen as lifetime companions; their selection never entailed any strategy for financial speculation, nor desire to "complete a set" or check a box on some imaginary list of desiderata. What is perhaps most striking in this light is that Mrs. Smith has recurrently chosen to share her life with what art dealers sometimes refer to as "difficult" images, and what we might more bluntly recognize—in the case of two extraordinary Picassos— as "tough women." The large *Bather* of 1908–09 (p. 33), and the *Woman Dressing Her Hair* of 1940 (p. 37), are pictures of unquestioned historic importance, but neither is even close to being conventionally pleasing or reassuring; their affronts to traditional notions of harmonious beauty are not something every collector would appreciate coming home to. Treasuring the power of such creations as its own form of beauty is evidence for a tough-minded independence of spirit that we might infer—rightly, I think—underlies this collector's gracious warmth and kindness.

Picasso has been one of Mrs. Smith's favorite artists, and she has collected more than a dozen of his works in a variety of moods, scales, and mediums. The *Bather* and *Woman Dressing Her Hair* both seem to stress the monumental and specifically sculptural side of the artist's imagination. The shaded, curving volumes of the *Bather* are closely tied to Picasso's experiments with translating nascent Cubism into sculpture in 1909 (as in the bronze *Woman's Head [Fernande]* of 1909, already in the Museum's collection), in the same way that the massive, boldly illuminated bulk of the *Woman Dressing Her Hair* recalls the artist's return to modeled sculpture earlier in the 1930s. Each of these images draws part of its raw and unsettling power from the way in which impossible anatomies assume imposing corporeality. In the earlier work the resulting element of the grotesque seems more incidental, even gratuitous, but by 1940 such visual paradoxes had come to serve as indispensable aids to imaging the world of *Guernica* and after.

By contrast, the two Picasso drawings and one print Mrs. Smith has assembled on the theme of the "sleepwatcher" (pp. 71, 75, 77) stem from a sharply different area of the artist's imagination, concerned with a more tender sense of intimate eroticism and with the fascination of looking—possession by the desiring eye as opposed to the haptic, tactile sense of grasping with the modeling hand. Finally, in sculpture itself, Picasso's wit and his recurrent practice of giving new metaphorical life to found objects are amply represented, both by *The Glass of Absinthe,* with its real sugar strainer as an accessory (p. 57), and by the shards of old pots that shaped the belly and breasts of *Pregnant Woman* (p. 59). (Mrs. Smith long ago gave both sculptures to the Museum.) The mystery of beguilement and the punch of intelligent humor are thus honored in this select collection as much as the more profoundly troubling power of Picasso's ways of reshaping and deforming the visible world.

Some of the affinities within the collection, such as the thematic linkage of the three Picasso sleepwatchers, are insisted upon in the way Mrs. Smith displays the pictures. Yet she is equally insistent in making juxtapositions of contrast: the unrelentingly tough *Woman Dressing Her Hair* shares a wall, for example, with a picture she recognizes as being opposite in its sweetness and sentimentality, Picasso's *Paloma Asleep* (p. 39). Similarly, the subtle layerings of the quietly contemplative and relatively somber *The Table* by Braque (p. 21) hang in a corner of Mrs. Smith's living room near the exceptional Matisse *Still Life with Aubergines* (p. 29), which could not be more distant in its splashy, thinly brushed, and high-keyed exuberances of blues, yellows, and reds. The entrance to an adjoining room is meanwhile guarded by one of the more haunting icons of Surrealist sculpture, the spidery figure of Giacometti's *Hands Holding the Void* (p. 47), with its cagelike frame and overtones of terror and mystery, while within that room awaits Picasso's earthier and more

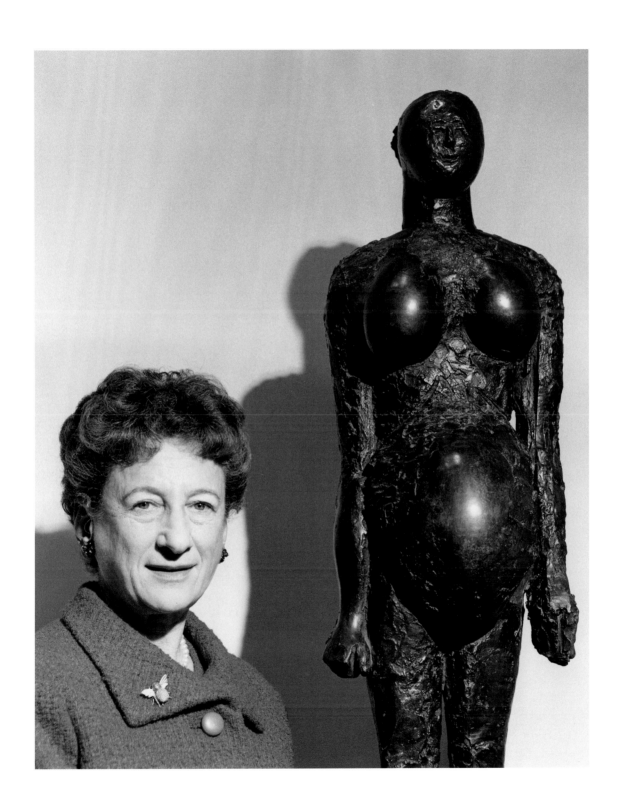

good-humored embodiment of fecundity, the *Pregnant Woman*. Rigid ectomorph and pneumatic endomorph, these idols of emptiness and fullness play off each other in their opposing senses of the uncanny.

As these oppositions might suggest, Mrs. Smith has chosen to live with the differing pleasures and powers of both sunlight and shadow. The Matisse *Still Life with Aubergines*, painted on the Mediterranean coast, brings the expansiveness and energies of the landscape indoors into the play of patterned, decorative energies; it finds its companion in an earlier Matisse painting from the same locale, dealing more directly with sunlit dazzle. On the wall of Mrs. Smith's apartment devoted to a grouped series of brightly colored smaller Fauve works (pp. 23, 45), the highlight is the exceptionally charged and vivid *Landscape at Collioure* (p. 27), whose aerated rendition of intense southern radiance and colors Matisse used as a key starting point for his evocation of an exotic earthly paradise in the *Bonheur de vivre* (Barnes Foundation, Merion, Pennsylvania) a year later. The same room contains, however, Degas's earth-toned abstract visions of the autumnal Burgundy countryside (p. 67) and Seurat's grainy chiaroscuro transformation of a banal corner of a pathway into a silent poetics of half-light (p. 83), and just around the corner lies the deep, almost nocturnal exploration of underwater timelessness in Monet's *Water Lilies with Reflection of a Willow Tree* (p. 31). Moreover, Mrs. Smith has evinced a deep affection for the twilight reveries of Odilon Redon, acquiring a painting and two charcoal drawings (pp. 41, 79, 81) that move far away from optical sensations, on which Seurat, Degas, Monet, and the young Matisse still based their work, into a darker world of near-religious symbolism and mystical portent.

Perhaps the most exceptional imagining of nature in the collection, however, is the huge and thrilling *Picture with an Archer* (p. 25) painted by Kandinsky in 1909. Taking his cues equally from the Fauve painters' shadowless intensification of color and from vernacular sources such as folk paintings on glass, Kandinsky conjured a mythic world where deeper and lighter hues alike burn with a midnight fluorescence and dramas of heroism unfold in a terrain of geological phantasms and archaic Eastern architecture. In this dreamland, darkness achieves radiance and the jeweled miniaturism of fairy-tale illustration proves adaptable to ambitions for epic spiritual exaltation. Within a collection of modern art strongly dominated by France, this exceptional eruption of the Northern imagination unsettles the mix and confounds generalizations about Mrs. Smith's tastes, even as it reaffirms the absence of any categorical blinders on the eye for exceptional quality that has guided her every acquisition.

In all these senses and more, the present exhibition hopes to illuminate the distinctiveness and singularities of this wonderful collection. Yet it is crucial to recall that we also celebrate Louise Smith's generosity in determining that the collection should eventually loose those very boundaries of separateness, and (except for Braque's *The Table* and Monet's *Water Lilies with Reflection of a Willow Tree*, destined for The Metropolitan Museum of Art) merge into the larger whole of the painting and sculpture collection of The Museum of Modern Art. It has always been the policy of the Museum to present its collection of painting and sculpture as a chronological, synoptic overview of the history of modern art, integrating donations and bequests from all donors into a single stream, rather than isolating and preserving separate personal collections. Mrs. Smith, acting in the tradition established first by the bequest of Lillie P. Bliss and brilliantly continued by many other trustees of the institution, has committed her promised gifts to the furtherance of that ideal of historical continuity.

In recognition of her great generosity, the Museum has been pleased to create the Louise Reinhardt Smith Gallery within the display of the painting and sculpture collection. Since that gallery was named, it has held the Kandinsky series The Four Seasons, and it is expected that one day it will also hold the magnificent *Picture with an Archer*. The Matisse *Still Life with Aubergines,* however, will not remain nearby, but will join the Museum's *Goldfish and Sculpture* of 1912, just as the *Landscape at Collioure* of 1905 will pair tellingly with the Museum's *La Japonaise: Woman beside the Water,* painted that same summer. Similarly, the Giacometti *Hands Holding the Void* will elsewhere join with such related 1930s masterworks by the artist as *The Palace at 4 A.M.* The result will be the further deepening, expansion, and enrichment of what is arguably the fullest and most exceptional record of modern visual creativity in the world. The way in which The Museum of Modern Art presents this record inevitably reflects—that suspect word again—the personal tastes of the patrons who, like Louise Smith, have helped to form it. But it also speaks of a shared faith, which Mrs. Smith has so brilliantly reaffirmed by her promised gifts, in a vision of the modern spirit in art that, growing organically through the years as the sum of many contributions, subsumes and transcends the particular passions of any one individual's selection.

Kirk Varnedoe
Chief Curator
Department of Painting and Sculpture

MASTERWORKS FROM THE LOUISE REINHARDT SMITH COLLECTION

Commentaries by Kirk Varnedoe,
Magdalena Dabrowski, and Kadee Robbins

GEORGES BRAQUE
French, 1882–1963

The Table (Le Guéridon)
1921–22

Exhibited at the Salle d'Honneur dedicated to Georges Braque at the Salon d'Automne of 1922, *The Table* is the first of a series of vertical *guéridons* (decorative still lifes on a round table) that the artist began in 1921 and continued to modify until 1930. Preferring the "manual" space of the still life, an intrinsically static and hence more surveyable subject, to the more "visual" space of the landscape, Braque had primarily devoted himself to this genre. In the 1920s, divorced from his partnership with Picasso, Braque began to formulate a more personal vision; his prewar fascination with an intellectual experience of form and space gave way to the rich, if subdued, paint and bolder, fuller forms of his post–World War I Synthetic Cubism. In this image Braque establishes a composition constructed with the staples of his still-life repertoire: table, fruit bowl, staves of sheet music, and a musical instrument. Though the space of the wood-paneled room is flattened by the backdrop of the black screen, the heavy tripod table provides an anchor of tangible weight and depth that many of his prewar still lifes do not possess. Yet Braque harks back to these earlier compositions in his use of the craftsman's graining comb to produce the *trompe-l'oeil* woods of the table and guitar—a trick that evokes his original *papiers collés* and the blurring of boundaries between manual craft and cerebral abstraction that they implied.

While the fragmented, multilayered organization of lines and planes of *The Table* adhere to Cubist spatial constructs, the image also suggests the sobering influence of a rival movement—the *rappel à l'ordre* that affected the postwar Parisian art community. Braque's *guéridons* as a whole, more naturalistic and more accessible than his earlier works and characterized by an air of restraint, subtly manifest this conservative retrenchment. The general moderation and quiet austerity of this composition as well as the specifically neoclassical rendering of the lower half of the image, both in the fluting of the wall panels and the column-shaped base of the table, hint at the presence of postwar reconsiderations within a larger Cubist framework.

K.R.

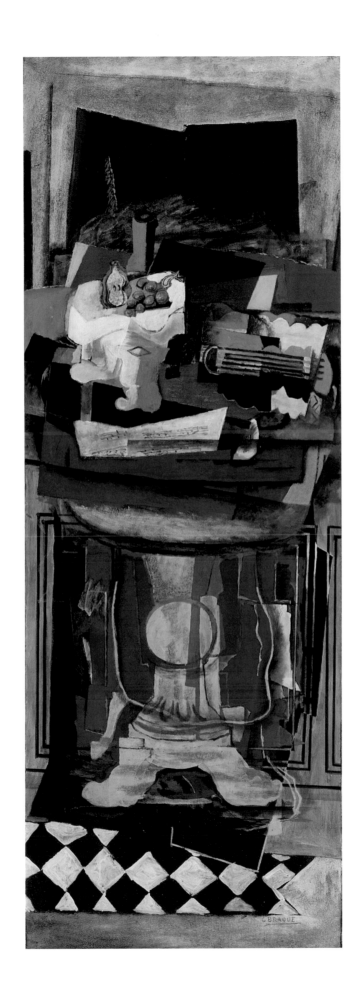

ANDRÉ DERAIN
French, 1880–1954

Portrait of Lucien Gilbert
1905

Lucien Gilbert, architect and amateur painter, was a great friend of Derain and Vlaminck from their early years in the Parisian suburb of Chatou and the first collector of their work. This portrait, painted when Derain was still based in Chatou, presents Gilbert as a young bourgeois, neatly attired in a suit, necktie, and bowler hat. A related Derain work, dated also to 1905 (The Metropolitan Museum of Art), portrays Gilbert outfitted in a like manner and with a similarly turned head and sideways glance. Mrs. Smith's picture, however, is remarkable for its foreshortened and cropped pictorial space and for its unusual "bird's-eye" viewpoint, which results in the slight facial distortion, seen in the exaggeratedly upturned nose.

Despite the unorthodox perspective, *Portrait of Lucien Gilbert* contains little hint of the radical innovations associated with Derain's work of 1905. This pivotal year encompassed both a revolutionary summer spent collaborating with Matisse in Collioure (see p. 26) and Derain's first trip to London in the winter, which resulted in a large group of opulent Fauve cityscapes. Though Derain scholar Georges Hilaire classifies this image as a Fauve portrait, it lacks both the luminosity and the deliberate disharmonies of high-key color typical of full-fledged early Fauve images. Furthermore, executed in a finished Gauguinesque style, it has little affinity with either the Neo-Impressionist "broken touch" approach or the improvisational quality visible in other Fauve works by Derain from 1905. Probably painted before Derain's groundbreaking months in Collioure, Gilbert's face is reminiscent of those in the earlier canvas *The Ball at Suresnes* of 1903 (Saint Louis Art Museum), where Derain portrayed his self-image with a similar sideways glance. Anticipating the tonal zones and distinct linearity of his 1906 portrait *Dancer at the "Rat Mort"* (Statens Museum for Kunst, Copenhagen), Derain's depiction of Lucien Gilbert in many ways also points toward the classic, flat-color Fauvism of 1906 and 1907.

K.R.

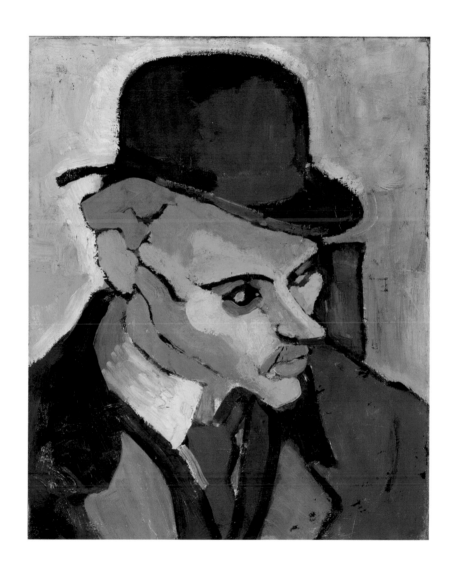

VASILY KANDINSKY
French, born Russia, 1866–1944

Picture with an Archer (The Bowman)
1909

Described by Alfred Barr as "lyrical, musical, dramatic" when first exhibited at the Museum in 1958, this painting is remarkable for its large size, innovative style, and vibrant color. The composition, executed in 1909 in Murnau (near Munich) after Kandinsky had been living in that region for over a decade, relies on the principle—learned from Fauvism—of abandoning traditional spatial conventions in favor of juxtaposing areas of color disassociated from the precise definition of form. A certain sense of depth is conveyed by the vigorous expressionist brushwork that creates a rich surface in relief. The specific narrative role of the figurative motifs depicted is of secondary importance to the intense color scheme; together they establish a powerfully dramatic effect and an ominous mood that invites the viewer to interpret the mysterious subject matter. Despite the painting's descriptive title, its visual impact alternates between an almost purely pictorial construction, in which the landscape and figures are absorbed into the sumptuous mass of explosive color that describes an outdoor scene of a rider on horseback, and a narrative scene.

The rider was Kandinsky's favored subject in the pre–World War I years, and this work is one in an important sequence, beginning with the 1903 painting *Blue Rider* (private collection, Zurich), continuing with several depictions of apocalyptic riders, and culminating in the cover image of the *Blaue Reiter Almanac* (a compendium of essays on art edited by Kandinsky and Franz Marc in 1912). Here, the archer turns uncharacteristically backward, aiming his bow at an unknown pursuer while galloping through a semiabstract landscape.

Awe-inspiring in its grandeur, the landscape is punctuated by several figurative motifs: a fragment of a Russian town with onion-domed towers, a group of people in Russian dress, and a strangely shaped tree. The picture's large scale is emphasized by an enormous vertical shape, like a bizarre tree trunk or a monolithic rock (which Will Grohmann compared to landscape formations in Capadocia, Turkey) that looms grandly over the composition. This form's imposing stability contrasts sharply with the dynamism of the archer and creates tension among the compositional elements while unifying them into a harmonious, mysterious whole.

These figurative motifs express Kandinsky's nostalgia for his native Russia and relate the painting to his works of the early 1900s, especially his "colored drawings." They also stylistically, and to a degree conceptually, point to Kandinsky's most important works of the following years, among them *Compositions I, II,* and *III* of 1910–11, which repeat these figurative motifs, spatial definitions, and rich, exuberant color.

M.D.

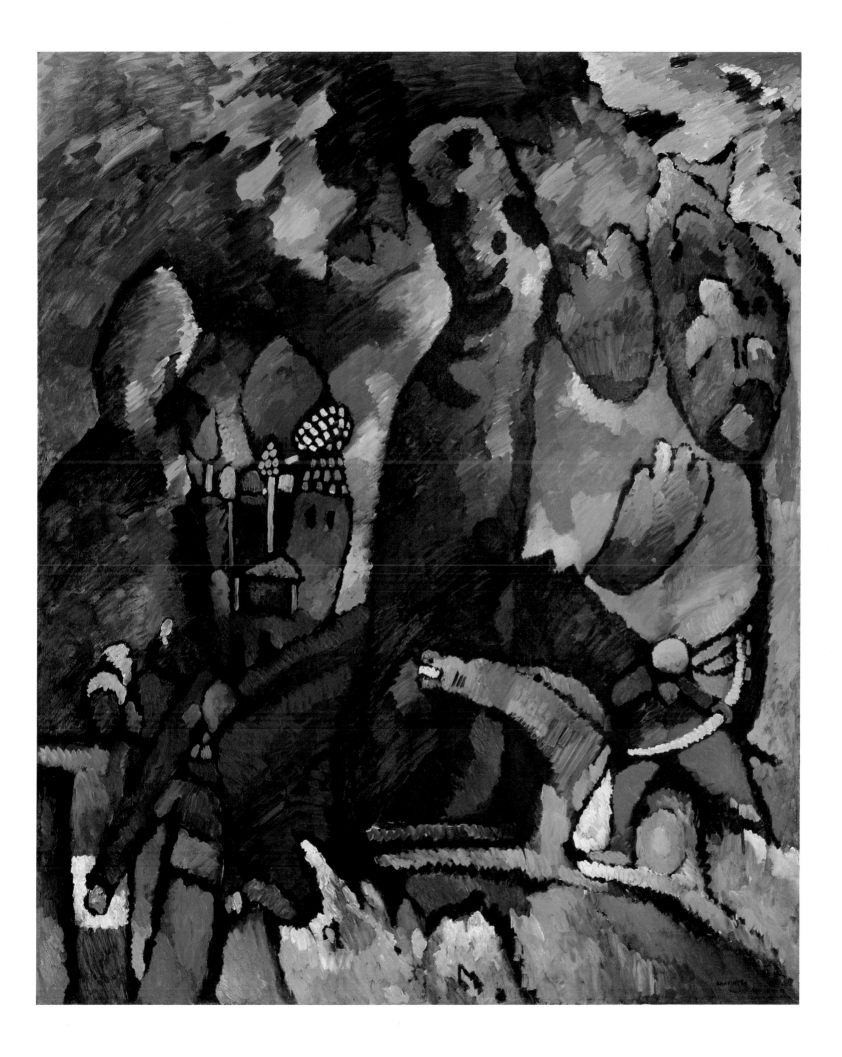

HENRI-ÉMILE-BENOÎT MATISSE

French, 1869–1954

Landscape at Collioure

1905

This small but brilliant and energetic landscape was executed during the summer of 1905 in Collioure, a small village on the Mediterranean coast, not far from the border between France and Spain. Its depiction of a central space leading inward between two groups of trees, toward a possible hint of the sea over a far hill to the left of center, later served as a prime point of departure for the landscape setting in Matisse's huge Arcadian scene of 1905–06, *Bonheur de vivre* (Barnes Foundation, Merion, Pennsylvania).

As Jack Flam has noted, Matisse came to Collioure that summer with two opposed models of Post-Impressionist painting fresh in his mind, from the two retrospectives of Vincent van Gogh and Georges Seurat that had been a part of the Salon des Indépendants in Paris in the spring. Through the intermediary of Seurat's disciple Paul Signac, Seurat's "scientific" divisions of color and methodical, modular brushstrokes had dominated Matisse's major work of the previous summer in St.-Tropez, and at the outset in Collioure, Matisse continued to use a Signac-style mosaic of small blocks of hue. Several influences then seem to have conspired to forge a change. Though André Derain had come with Matisse to Collioure to learn from him, Matisse may have also been goaded by the younger, more head-strong Derain, who impatiently abandoned Neo-Impressionist methods and began to draw heavily on van Gogh's more aggressively linear and rhythmic brushwork. Also, both painters were put back into immediate contact with Gauguin's legacy when they visited with his nearby friend Daniel de Monfried, who owned some of the artist's major Tahitian canvases as well as manuscripts and drawings.

In incisive analyses of this work, John Elderfield has pointed to the influences of both Gauguin and Cézanne in its arbitrary color shifts. *Landscape at Collioure* leaves orthodox Neo-Impressionism far behind in this regard and in its aerated, explosive flurry of directional brushstrokes. Elderfield points out, too, how—for all the brilliance and independence of the color—the sense of brightness here depends in large measure on the allover intrusion of bare canvas. Matisse purposefully pulled back from filling in bare areas, eliminated any softening shadows or intermediary tones, and created virtually no solid points of rest for the eye: the strokes resist cohering to form fields or to denote forms. The result is a picture which, in contrast to the suavely refined paradise of the *Bonheur de vivre*, has a coarse physical energy that still retains the shock of direct encounter with hot summer light in the South. An intermediary, second version of Mrs. Smith's landscape (in the Statens Museum for Kunst, Copenhagen) is in this regard stylistically more "advanced," calmer, and more organized; as a consequence it lacks the raw energy of this exceptional picture.

K.V.

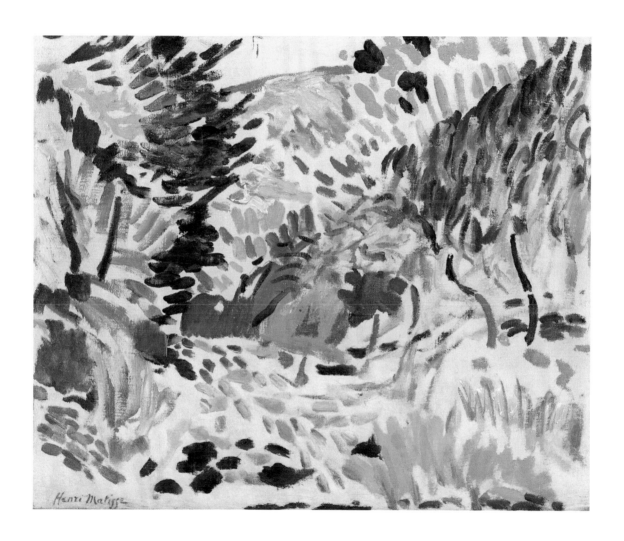

HENRI-ÉMILE-BENOÎT MATISSE

Still Life with Aubergines
1911

When Matisse showed this painting at the Salon d'Automne of 1911, referring to it as an *esquisse décorative* (decorative sketch), the critic Louis Vauxcelles felt deprived. "Let's be frank," he said, "There's practically nothing there." He assessed the picture as a quick preparatory sketch and held that Matisse had no business showing it. "If that continues," Vauxcelles said, "Matisse will soon give us a blank canvas." Though we may disagree about the conclusions the critic drew—there is a great deal to give up here before one approaches virgin fabric, and the loose thinness of the handling now seems pleasurably agitated—he was right in one respect. This was very likely a preparatory study for a much larger and more ambitious picture, the *Interior with Aubergines* now in the Musée de Grenoble; in that large interior the same arrangement of eggplants, pears, vase, and sculpture sits on a table before the same fabric-draped screen in the center of the room.

There are, however, enormous differences between the conception and feeling of this sketch and the larger, far more expansive and crowded picture. The distemper paint of the *Interior* is matte and opaque, in contrast to the soaking, thinned-out medium here, which allows the agitation of every stroke to become a part of the decorative pulse of the scene. Where the larger picture is built in terms of emphatic contours, linear patterns, and silhouettes, in Mrs. Smith's picture the energy of line is decidedly secondary and forms are more often fringed with breathing zones of canvas. Everything is also in higher key here: a more powdery blue dominates against a lighter green in the main fabric, and the secondary cloth to the right is more yellow here, but more ochre in the full interior. The creamy tones of the vase and the white plaster figure are also far closer here—this seems to have occasioned the extraordinary aura of blood-red strokes that set off the miniature man.

Matisse frequently included his own sculpture in his still lifes, but the plaster figure here is apparently an example of the *écorché* (flayed figure) used frequently in art schools as a guide to anatomy (and then thought to be by Michelangelo). As various Matisse scholars have pointed out, Cézanne once included this *écorché*, in juxtaposition with a plaster Cupid, in a still-life painting Matisse could well have known. In the Cézanne as well as here, the flayed figure seems to introduce—perhaps as a surrogate for the artist—a suffering human presence. John Elderfield has suggested that when painting in Collioure in the summer of 1911, Matisse transferred the splendor of the sunlit southern landscape, which had formerly dazzled him (see p. 27), into this picture and the large *Interior*, and that, within the context of a synthesized domestic paradise, this agonized human presence takes on more substantive meaning.

K.V.

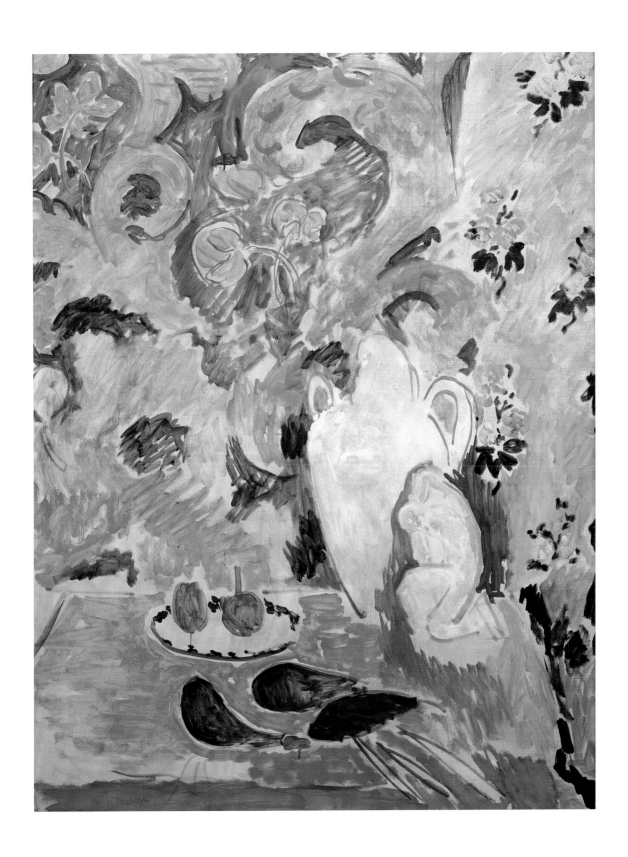

CLAUDE-OSCAR MONET
French, 1840–1926

Water Lilies with Reflection of a Willow Tree
(Nymphéas, reflets de saule)
1916–19

Monet's series of Haystacks (1889–91) and Poplars (1891) both attest to the quasi-scientific approach through which he systematically depicted the most transient of subjects. Neither of these projects, though, comes close in scale or innovation to his series of paintings of water lilies, which obsessed him almost exclusively over the last two decades of his life. The numerous canvases span essentially two periods: during the first, from 1903 to 1908, Monet painted a group of smaller pictures that were shown in an exhibition at the Galerie Durand-Ruel in 1909 titled *Les Nymphéas, paysages d'eau*. The later Water Lilies, executed from 1914 until the artist's death, belong to a vast decorative cycle of mural-size canvases that present the entire circuit of Monet's pond at Giverny under varying conditions. These large works were designed to create (in Monet's words) an "enveloping painted environment"—an intention that was realized with Monet's 1922 donation to the French state of nineteen canvases displayed in two oval rooms at the Orangerie in Paris.

Mrs. Smith's picture, part of a series dedicated to the reflection of a willow tree, demonstrates the increasing dominance of the water itself within the later compositions. Whereas in earlier canvases Monet depicted a scene in its entirety, recording the pond's bank in the background and the Japanese footbridge rising above the lilies in the foreground, as the series progressed he focused increasingly on a sheet of water until the bank was only implied by fragments mirrored on the aqueous surface. The pond alone sustained Monet's compositional needs and even connoted the act of vision itself; as Charles Stuckey has noted, with its inverted reflection the water becomes a metaphorical retina. However, with the disappearance of the rim of earth that separates the actual from the ethereal, the essential dichotomy of these works is increasingly clear. They are at once the epitome of strict realism, recording nature in all its minute nuances, and creative translations of the actual subject, a nearly abstract vision of Monet's own exotic Eden, with lilies defying gravity and rarefied waters expanding in all directions.

It was for this lack of spatial depth that Monet's later Water Lilies were seen as merely decorative by an avant-garde dominated by Matisse and Picasso and focused on the formal experiments of Cézanne. Popular opinion soon followed suit and the Water Lilies were dismissed as old-fashioned. This judgment was reversed with the emergence of Abstract Expressionism after World War II, when the monumental scale and subjective vision of the Water Lilies were recognized as strikingly modern—in the words of critic Clement Greenberg, "the first seed planted, the most radical of all."

K.R.

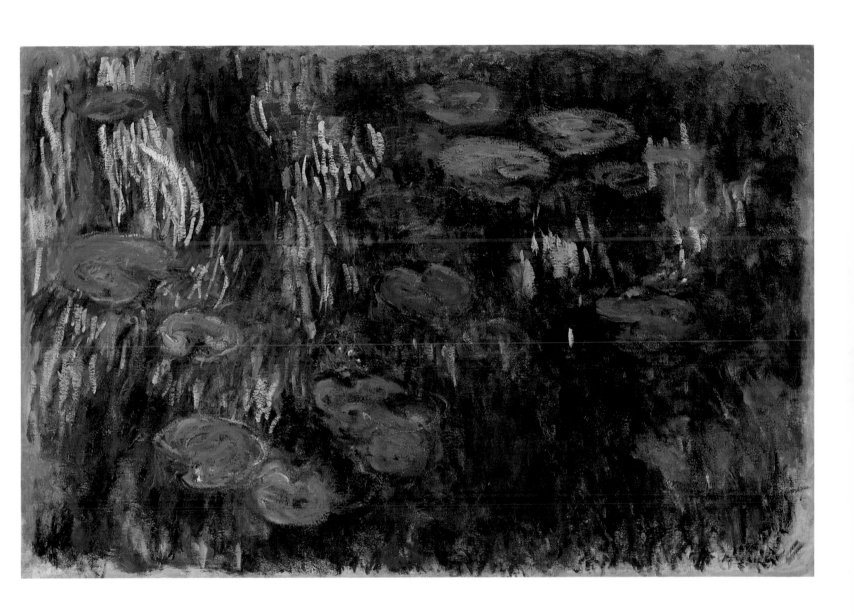

PABLO PICASSO

Spanish (died Mougins, France), 1881–1973

Bather

1908–09

Painted late in 1908 and early in 1909, this large canvas represents one of Picasso's most elaborate and imposing attempts to expand on the innovations of the Museum's *Les Demoiselles d'Avignon* by formulating a new anatomy consistent with the precepts of emergent Cubism. *Bather* followed shortly after Georges Braque's *Large Nude* (private collection, Paris), which tackled some of the same problems in weaker fashion, but it anticipated, in ways both general and specific, aspects of Picasso's imagery that would evolve decades later.

As elsewhere in Picasso's depictions of women (see, for example, Mrs. Smith's *Woman Dressing Her Hair*, p. 37), the self-consciously harmonious and seductive grace implicit in the "beauty pose" collide so incongruously with Picasso's radical restructuring of anatomy that the combination yields a disorienting, even grotesque effect. Part of the shock comes from isolating this impossible personage within such a blandly plausible seaside vista. Instead of uniting figure and ground in the shallow, relieflike array of faceted forms more typical of Picasso's work at the time, the proto-Cubist reconfigurations here are confined by the body's closed contours in a way that recalls the freestanding Cubism of Picasso's one contemporary sculpture—a modeled head that also shares with the *Bather* an atypical dominance of curves and arcs in the articulation of its forms. This antinaturalistic anatomy is then set against a deep, uninflected space, which seems less a vestige of the barren beaches of Picasso's Blue Period than an anticipation of his monstrous visions of monumental bone figures set on oneiric littorals in the 1920s.

In contrast to the colossally ponderous, thick-limbed types who had dominated Picasso's figural work in 1908, this body has a hard musculature that emphasizes the mobile and cleft joints of its relatively spindly limbs. Yet it is disproportionately thickened by Picasso's appending, along its right edge, extra slices of the (in principle obscured) back and far buttock—as if to include a three-quarter rear view as well. These passages appear anomalous: remove them and the figure has a far more consistent and natural, if strangely stylized, anatomy. Leo Steinberg and others have pointed out, however, that their seeming oddity links the *Bather* to Picasso's ongoing obsession with defeating the standard limits of apprehension and optical "possession" by simultaneously depicting the front and back, or visible and invisible, sides of the body. Similarly, Robert Rosenblum has pointed out that, in the sharp separation of light from shadow that divides this face, Picasso first manifested the fusion of frontal and profile views that would later become an important expressive device in images such as the Museum's *Girl before a Mirror* of 1932. The artist's more "advanced," more fully Cubist reprise of virtually the same pose a few months later (in the spring 1910 *Nude* in the Albright-Knox Art Gallery, Buffalo, New York, as Edward Fry first noticed) has actually lost the pungency of such raw inventions.

K.V.

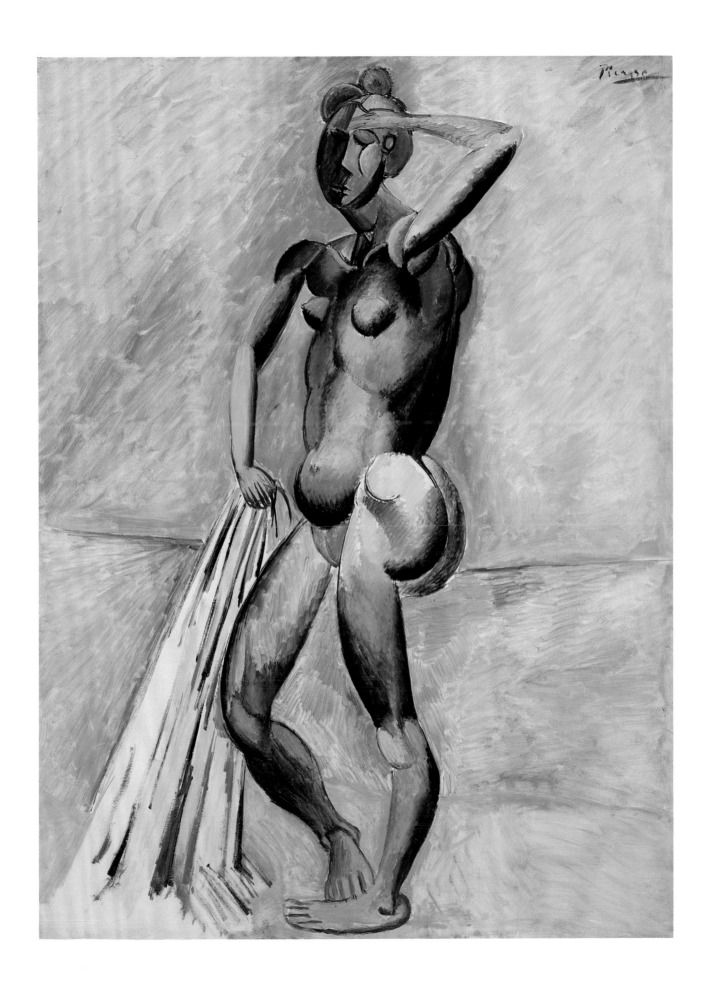

PABLO PICASSO

Head of a Young Man
1915

In the years surrounding World War I, when his work in collage and painting was dominated by the flat, abstract planes of Synthetic Cubism, Picasso also produced a series of works (usually drawings) in a more naturalistic vein, often marked by a classicizing linearity that recalls the French nineteenth-century painter Jean-Auguste-Dominique Ingres. This small and tender study of an idealized head belongs to that mode of alternative naturalism, though the "slip-fault" dislocation that seems to shift the right side of the face below alignment with the left betrays a residual Cubist inflection. Sometimes dated to 1915, it has also been associated by Josep Palau i Fabre with a group of drawings Picasso made in Avignon in the summer and autumn of 1914. In a large unfinished canvas from Avignon, *The Painter and His Model* (Musée Picasso, Paris), the head of the artist—presumably a self-portrait in spirit, if not in appearance—bears some resemblance to this one.

<div align="right">K.V.</div>

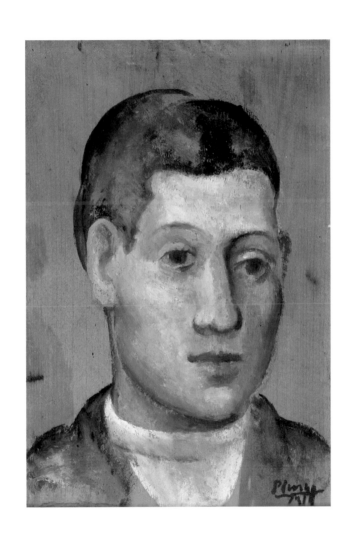

PABLO PICASSO

Woman Dressing Her Hair (Femme assise)
1940

This painting is generally regarded as the masterpiece of a particularly grim moment in the life of the artist and of his adopted country. It was painted in Royan, a small village on the Atlantic coast near Bordeaux, in June 1940, when France was being overrun and then occupied by the armies of Nazi Germany. The association between those events and the painting has become—like the association with the ostensible model for the figure, Picasso's mistress the photographer Dora Maar—nearly inseparable from any attempt to articulate its meaning and impact. Some have even discerned, in the twisted rhythm of the pose, the subliminal echo of a swastika—a reading Picasso sharply refuted.

Much is known of the background circumstances of the work: Picasso's hurried shuttlings between Paris and Royan along roads choked with refugees, for example, and his execution of numerous preparatory drawings, among them graceful wash evocations of the nude, which eventually alternated and mingled with abstracting studies of a human skull. Yet ultimately we need no such supporting documentation to recognize the painting's compressed emotional drama, and none can pretend finally to explain its enigma. Similarly, one can cite many lineages to which this woman could belong. She descends in some respects from the agonized weeping women that followed the creation of *Guernica* in 1937, and she echoes as well the horrific bone anatomies Picasso devised for monumental female figures in the 1920s. Yet the mood, wholly devoid of histrionics or simple menace, owes nothing to either series.

Already in early works such as *Bather* of 1908–09 (p. 33), Picasso had begun to explore what might be gained by grafting together abstract deformations and the conventions of realistic depiction. Variations on that continual experiment—in sculpture and in collage, for example—became a mainspring of his art; here the hybrid, redefined in a potently sculptural, dramatically illuminated vision, yields emotional sustenance and psychological depth not imaginable by other means. The motif of the casual vanity of the toilette, enacted by a being so grotesquely misshapen, might be merely cause for nasty mirth over a blind lack of self-awareness. Yet this figure, with all its attributes of repulsive clumsiness— bestial snout, cleft face, stumpy hands, distended belly, and cloddishly outsized feet—is modeled in textured light and shadow with the solemn care evident in a Zurburán still life. It achieves, within its claustrophobically diminished "room," a monumental yet tender sense of calm self-possession that transmutes our smug derision into graver uncertainties about the nature of the beautiful and the tragic. The picture draws its profound power from complex conjunctions between nobility and monstrosity, which are fused without being resolved, and also between sympathy and cruelty in the creator and viewer alike.

K.V.

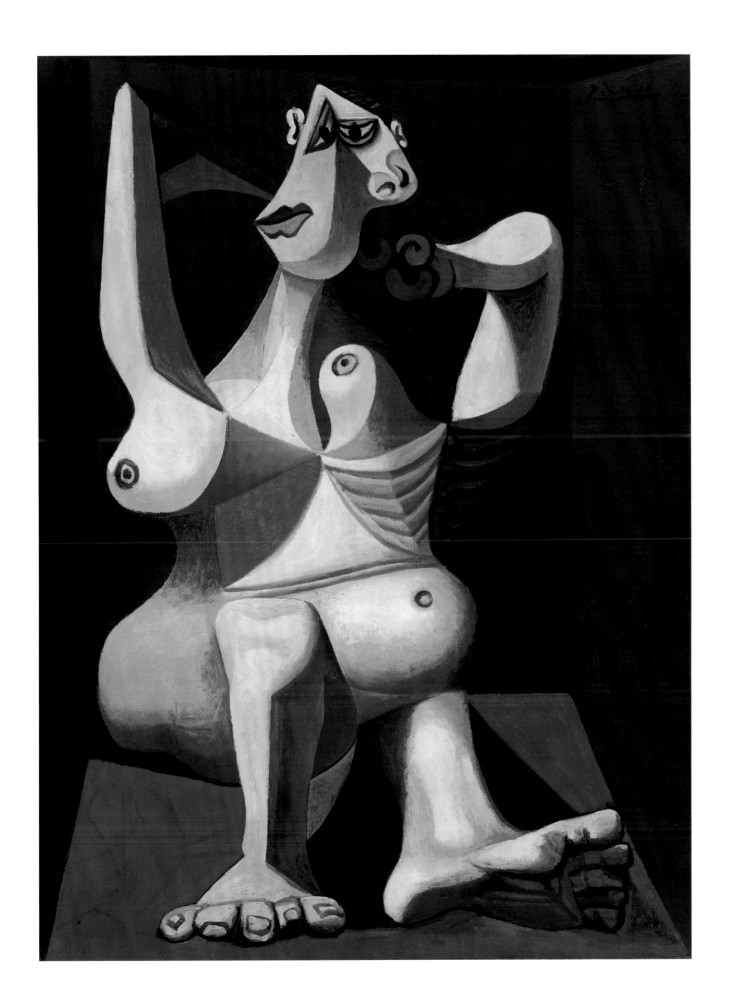

PABLO PICASSO

Paloma Asleep
1952

Picasso had several children with different partners at widely separate stages in his life, but he seems to have taken particular pleasure in the early childhood of the son and daughter, Claude and Paloma, whom he fathered with Françoise Gilot when he was in his sixties. As these two grew up in the South of France in the early 1950s, he delighted in fabricating puppets and dolls for them, in making assemblage sculptures from scraps that included their toys, and in showing them at play. As Werner Spies has pointed out in his book-length study *Picasso's World of Children*, Picasso typically shows these last progeny not in the formal, often costumed poses he imposed on his first children, but in an unconstrained liberty. The nudity and imposing physicality of Paloma in this view, and her self-possession within her own world, are leagues away from images such as *Paulo as a Harlequin* of 1924 (Musée Picasso, Paris). Slumbering just a few days before New Year's Eve in 1952, Paloma is a pointedly postwar cherub.

The motif of the sleeping female nude had been a staple of Picasso's art (see pp. 71, 75, 77), but several aspects distinguish this junior variant. The three-year-old's body lacks the sinuous rhythms and reverse-curve contortions that often suggest a psychic life within Picasso's dozing erotic anatomies (compare, for example, the convulsed dreamer, similarly "fenced in," of *The Balcony*, p. 75). Instead the limbs hang in a swimming posture that brings one arm over the crib's edge, beneath a straight head-to-foot line that speaks of utterly unruffled tranquility. Eros can never be wholly remote from Picasso's imagination, however; and the way the unself-consciously spread legs, still in shadow, frame the vaginal crease—alertly vertical while all else is in repose—may suggest his intuition of a latent, as yet untrammeled instinctual life.

K.V.

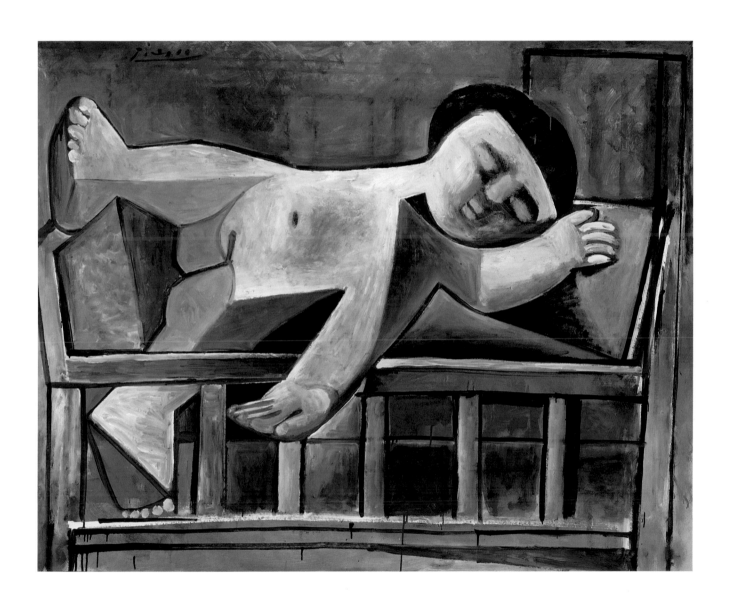

ODILON REDON
French, 1840–1916

Green Death
c. 1905

In its first form, Odilon Redon's painting *Green Death* was one of a series of lithographs inspired by Gustave Flaubert's *The Temptation of Saint Anthony*, a popular prose poem published in 1874 that poignantly expressed the fears and desires of *fin-de-siècle* France. Redon, perhaps seeking to capitalize on this popularity at a time when his own career was lagging, created three lithographic albums based on the text. These forty Temptation prints succeeded in bringing Redon breakthrough recognition. This image appeared in the second album, completed in 1889, and is the artist's best-known print from this series. It depicts the embrace and fusion of Lust and Death, incarnated as women, who have come to tempt the saint. The resulting monster retains elements of both seductresses: Death's skull sits atop the voluptuous female torso of Lust and the force of both is invoked in the gigantic serpentine tail.

In this more exotic color rendition, painted some fifteen years after the original, the somber black and white of the lithograph has been replaced by a rich palette of green and red (one that Redon repeated in several of his canvases of this period). While the lithograph took both visual cues and title, *Death: My Irony Exceeds All Others*, directly from Flaubert's text, in this later version Redon has discarded the literary title. Though he retains the image's basic form, the monster's torso is now distinctly masculine and all that remains of Lust are the faint roses that float in the mist above Death's gaunt face.

After a career of over twenty years dedicated almost exclusively to work in black and white and to the creation of fantastical lithographs and dreamlike charcoal and black chalk drawings referred to as *noirs* (see pp. 79, 81), Redon's embrace of color in the early 1890s marked a significant transition. From portraits of family members and patrons to the well-known series of floral still lifes, Redon's works in color carry a seemingly more accessible and less macabre iconography. The reemergence of this composition among the color works, however, suggests that the imaginary monsters and mythical figures of Redon's black-and-white past had not entirely vanished.

K.R.

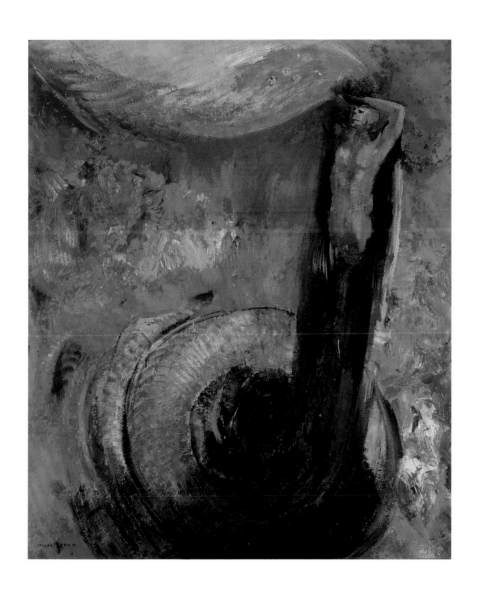

JACQUES VILLON
French, 1875–1963

Portrait of the Artist
1909

This 1909 self-portrait was completed just before Jacques Villon abandoned his early career as a satirical cartoonist. Renouncing his longstanding association with the popular journal *Courrier Français*, and ceasing to chronicle modern life as it unfolded at the Moulin Rouge and other *belle epoque* settings of fashionable Paris, Villon began, at this time, to consider himself a modernist artist. His turn to the traditional genre of the self-portrait implies his desire to advance beyond his cartoon repertoire and to associate himself with more serious artistic endeavors. The sideways, self-scrutinizing stare and the painting's unfinished quality capture his emerging identity at the hesitant juncture between his early lighthearted caricature and the carefully constructed Cubist and abstract canvases of his later years.

Villon's synthesis of disparate styles in *Portrait of the Artist* reveals his conflicting approaches to painting during this transition period. The bricklike brushstrokes, which Villon had discovered in the Neo-Impressionist painters, and the deliberately delineated planes of background, head, and foreground express the artist's preoccupation with pictorial structure and foreshadow his subsequent interest in the geometric decomposition of form. In contrast, his focused face peering through opposing planes of rectangular flakes maintains a core of intimist realism that is characteristic of his previous attempts at painting.

Coupled with the 1908 canvas *The Haulers* (private collection), in which Villon's handling first becomes markedly less fluid and more structured, *Portrait of the Artist* charts Villon's rising awareness of the formal concerns of his vanguard contemporaries. As Alvin Martin has noted, in both canvases Villon recalls Cézanne's use of constructive brushwork in establishing directional forces—a structuring method that would lead to the faceted planes of Villon's Cubist works.

K.R.

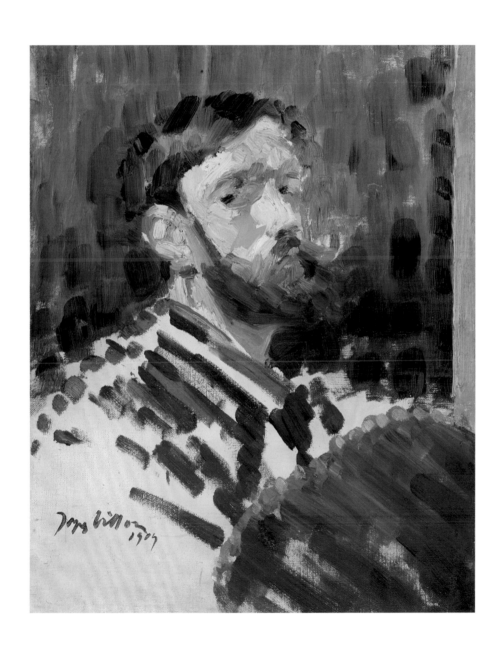

MAURICE DE VLAMINCK
French, 1876–1958

Portrait of Solange (formerly Portrait of Madeleine or Madeleine as a Child)
1905

Long misidentified as Vlaminck's eldest child Madeleine (an error that the painter, having attached no importance to the titles or dates of his canvases, never rectified), this image is one of the few in which the artist depicts his immediate family. This portrait of Vlaminck's second daughter, Solange, is rare also in the gentleness of the image and intimacy of the subject matter. Having developed in his early years a preference for landscape, the favored subject of Fauvism, Vlaminck maintained this bias throughout his career and rarely attempted portraits. The few examples of Vlaminck's experiments in this genre, however, reveal a characteristic harshness. In contrast to the violent red face of his *Portrait of Derain* (private collection, Mexico City), also completed in 1905, and his grim *Dancer at the "Rat Mort"* of 1906 (private collection, Paris), this portrayal of young Solange maintains a vivid directness but has been spared the typical brutality of Vlaminck's figurative Fauve canvases.

The image is executed in the flecked Neo-Impressionist brushstrokes of early Fauvism, a style that Vlaminck would sustain even after Matisse and Derain had abandoned it for the color-zoned, Gauguinesque approach of their later Fauve canvases. Most likely produced after Matisse and Derain's pivotal summer in Collioure, it displays the beginnings of the spatial compression that became an integral element of the Fauvist movement. Yet despite stylistic affinities, the tender subject matter perhaps precluded the ferocity—inherent in both his work and his disposition—that led Vlaminck to be dubbed the "essential Fauve."

K.R.

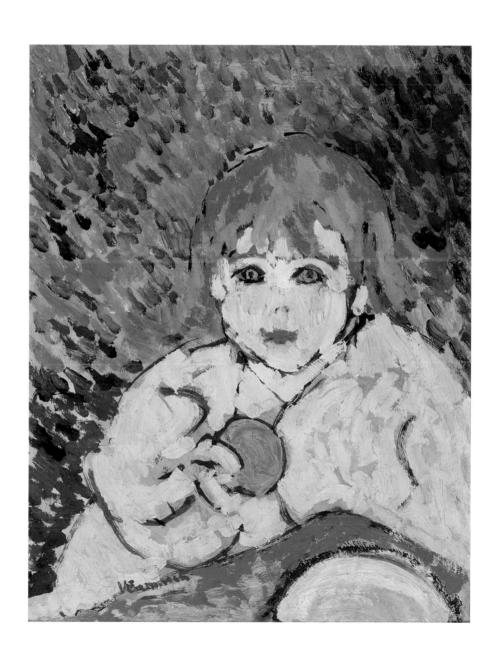

ALBERTO GIACOMETTI
Swiss, 1901–1966, to Paris 1922

Hands Holding the Void (Invisible Object)
1934 (this cast c. 1954–55)

By Giacometti's own testimony, this haunting sculpture of a woman greatly disturbed him and marked a turning point in his life as an artist. It was his first full-length figure and the last major work he made within the orbit of Surrealism; dissatisfaction with the modeling of this body helped propel him to begin once more to work from a live model and to base his art on seeing, as opposed to fantasy and memory.

Scholars have generally agreed that the figure borrows elements from Egyptian sculpture and tribal art (particularly one Solomon Islands sculpture in the Basel ethnographic museum). Additionally, the cagelike surrounding "throne" may conflate memories of early Italian madonnas with the influence of Malangan carvings from New Guinea. The ringleader of orthodox Parisian Surrealism, André Breton, followed the phases of this sculpture's creation with intense interest and recounted that a decisive impetus came from his and Giacometti's flea-market discovery of a peculiar military protective mask from World War I.

As Rosalind Krauss has pointed out, Breton's story is slanted toward his cherished notion that the greatest poetry arises from chance encounters and mysterious found objects, but Giacometti's later insistence that this half-crouching pose derived from that of a child glimpsed in the street suggests an opposite bias. After he had denounced his Surrealist sculptures as unworthy, Giacometti moved to assimilate *Hands Holding the Void* more closely to the naturalism of his later work, both by this tale of origin and by removing (from this 1954–55 casting of the 1934 plaster) an enigmatic animal head, avian or lupine, which originally adorned the middle crossbar of the "throne" and reinforced the sculpture's sinister air of Symbolist mysticism.

In all likelihood the title *Hands Holding the Void* carries an intentional pun in its French version: *mains tenant le vide* is very close to "*maintenant le vide*" or "now the void," implying the sense of uncertainty and impending crisis that the artist apparently felt in 1934. However titled, the work is profoundly enigmatic in mood. Wide-eyed and slack-jawed as if caught, Pompeii-style, in a moment of permanently astonished fear, this angular, insectile figure rigidly echoes its surrounding frame and is immobilized by the plank pressing on its shins—as if in rigor mortis a stiffened cadaver had been hoisted to verticality. As she perches precariously on the narrow, elongated chair that William Rubin aptly associated with the dream architecture of Giacometti's *The Palace at 4 A.M.*, menace and vulnerability commingle around this priestess of an unknown cult to form an atmosphere as troublingly elusive as the empty ether between her hands.

K.V.

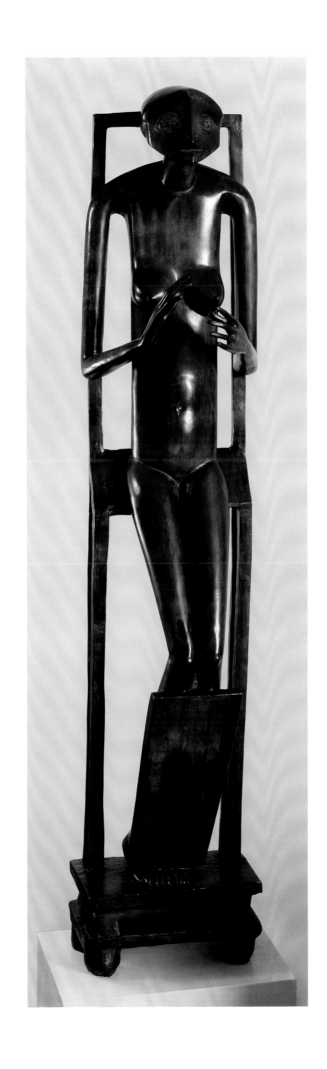

ARISTIDE MAILLOL
French, 1861–1944

Crouching Woman
1930

Maillol epitomizes the vein of classicism that recurs throughout modern art and is pursued by progressive spirits from Picasso to the postmodernists, yet constantly suggests antipathy to the modern and an atavistic denial of the ethos of progress. The possible conservative political implications of such regressiveness seem evident and troublesome in Maillol's case. Admired and encouraged by early modern pioneers such as Gauguin and Rodin, then consistently embraced as an exemplar of the French modern vision in the 1920s, Maillol became a favorite of the reactionary right in France in the 1930s and eventually a paragon of the politicized aesthetic associated with the Third Reich. Moreover, he assented to such a framing of his art and eventually became, along with André Derain and other artists, a problematic figure in the context of the German occupation of France.

Yet it would be facile to call this *Crouching Woman*, and her many relatives in Maillol's work before and after, simply conservative. The artist's roots lie in the Symbolist context of the 1890s, when his initial devotion to an ideal of the decorative expressed a valuation of hand craft and of art's relation to timeless values that were espoused by socialist movements of the day. The first small nudes he modeled in those years, and refined and enlarged for display in the early 1900s, posit a stolid, thick-jointed female anatomy that is the antithesis of the insatiable, anorexic fatal woman often associated with the *fin-de-siècle* and Art Nouveau. The relation to Gauguin's mannish Tahitian *vahines* is not coincidental; aside from likely direct influence, these figures (which were inspired, as all of Maillol's later work was, by the hefty proportions of Catalan girls from his native Roussilon region on the Mediterranean shore in the Southwest of France) reflect a shared search for archaic certainties in backward zones untouched by such urban fashions as feminism. Within that "peasant" or "primitive" spirit of deeply internalized passivity, the artist could also imagine a less troubled, blunter, and more primal sexual candor: despite her generalized volumes, *Crouching Woman* has, like Maillol's early *Night*, a surprisingly specific vulva.

If we see Maillol's women, as many of his admirers did, only in the healthy sunlight of Mediterranean harmony and classical revival, we risk missing the original involvement of their moody self-possession with a more nocturnal sense of dreaming mystery, and ignore the latent association between their heavy, simplified limbs and a concept of primitive power. Push the *Crouching Woman* and her some of cohorts in one direction and we border on the territory of Henry Moore; in another we approach the rural proletarians of Diego Rivera.

K.V.

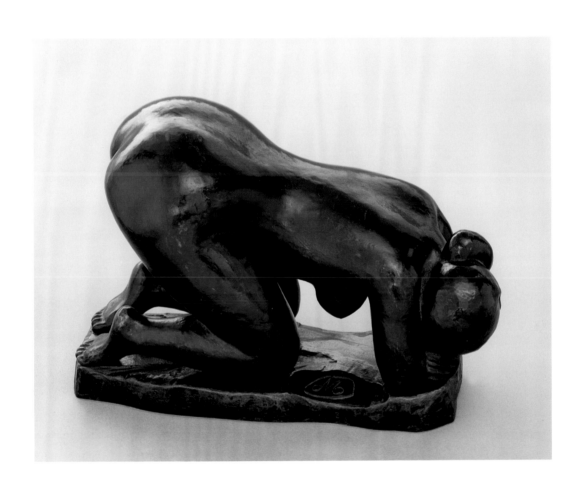

HENRI-ÉMILE-BENOÎT MATISSE

Standing Nude, Arms on Head
1906 (this cast 1951)

When Matisse came to maturity as an artist at the turn of the century, no artistic presence was more powerful than that of Rodin. Matisse chose to confront that presence head-on when he hired one of the master's former models in 1900 to pose for *The Serf*, a sculpture that demonstrates his keen attention to such Rodin figures as the *Walking Man*. The raised-arms posture in this smaller and more informal piece and the similar gestures of two previous 1904 sculptures by Matisse also superficially remind us of Rodin. Yet Matisse's enterprise as a sculptor was in many respects directly opposite. Rodin had placed great emphasis on movement, spurning the posed model in order to catch unorthodox gestures in motion and creating sculptures with no fixed relation to the earth (see, for example, his *Nijinsky,* p. 65). Matisse instead insisted on firmly rooting his figures to the ground, and precisely sought out conventional gestures associated with traditional art and professional studio posing. In fact, many of the poses of his sculptures (and of some paintings as well) were based on the kind of banal photographs then published as standard artist's aids. Beginning with such evidently unoriginal and only conventionally expressive motifs, he made them his own and gave them a different life by reconceiving the proportions, rhythms, and volumetric modeling of the bodies—often seeming to draw more inspiration from the models' awkwardnesses than from the anodyne ideal of beauty they aspired to embody. This figurine is a case in point: the stumpy legs, splayed breasts, and sharp counterthrusts of the haunches and chest have a less picturesque and far tougher effect than the standard "beauty pose" would otherwise yield.

Several of the sculptures Matisse made in this period relate directly to poses found within his contemporary paintings, and scholars have pointed to a resemblance between *Standing Nude, Arms on Head* and the leftmost figure in the *Bonheur de vivre* of 1905-06. Matisse investigated the two different mediums in tandem, and he said of this process that "it was done for the purposes of organization, to put order in my feelings, and find a style to suit me. When I found it in sculpture, it helped me in my painting." This does not rule out, however, that the parts of the dialogue might be consciously opposed. As Michael Mezzatesta has suggested, this *Standing Nude* sculpture resembles Matisse's woodcut *Seated Nude*, which was contemporaneous with the *Bonheur de vivre:* both nudes share an aggressive heaviness of inflection and pointedly blunt, ungraceful rhythm of articulation that reassert the earthier strengths the artist had distilled out of the lyrical creatures in his large painted idyll.

K.V.

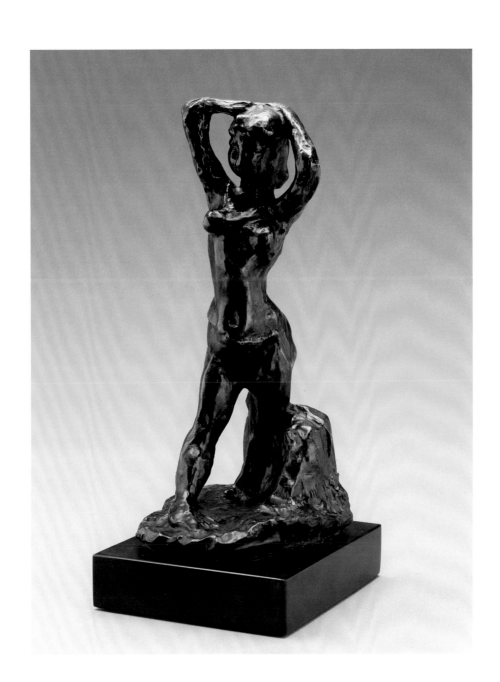

HENRY MOORE
British, 1898–1986

Mother and Child (No. 1)
1956

Mother and Child (No. 4)
1956

In the mid-1940s, Henry Moore wrote: "There are two particular motives or subjects which I have constantly used in my sculpture in the last twenty years; they are the Reclining Figure idea and the Mother and Child idea. (Perhaps of the two the Mother and Child has been the more fundamental obsession.)" This remark was made in the context of reflecting on the preparations for his first specifically ecclesiastical commission, the *Madonna and Child* for St. Matthew's Church in Northampton, England. Ironically, since that early obsession had yielded elemental icons that drew on ancient religious sculpture (both classical and non-Western), this religious work seems to have drawn him further into the realm of the secular and quotidian. John Russell said of the completed Northampton *Madonna* (1944) that it combined "the idiom of Easter Island and the idiom of George Eliot," and that the viewer oscillated between apprehension of a potent abstract composition and recognition of "a straight portrait of a well-built Yorkshire mother with a commendably sober taste in embroidery."

The Northampton commission was, among other things, Moore's first full-length rendition of the mother-and-child theme and his first draped figure. It served as a point of departure for his family groups of the following decade, and perhaps also for the altered imagery of the mother and child that characterizes these two small groups of the early 1950s. In them the massive blockiness that was basic to the primal, earth-mother spirit of his initial maternity scenes is replaced by open-work compositions that are more freely and complexly articulated in space. At the same time, the motif no longer simply embodies a relationship of primordial dominance and dependence, but now narrates one of dialogue and play.

We might speculate that the searing experience of World War II drove Moore, as it did other artists, away from the romance of the deep unconscious and into a new engagement with present-tense matters of life. Perhaps, too, as in the case of Picasso's contemporary painting *Paloma Asleep* (p. 39), new postwar ideas of child rearing and early education may have informed this more responsive exchange between infant and parent. Moore shared a widespread socialist interest in education as a part of social reform, and the postwar civic reconstruction efforts of the Labor government in Britain, as well as the birth of his own daughter in 1946, doubtless affected the new spirit of lightness and increased movement in these relatively informal small sculptures.

K.V.

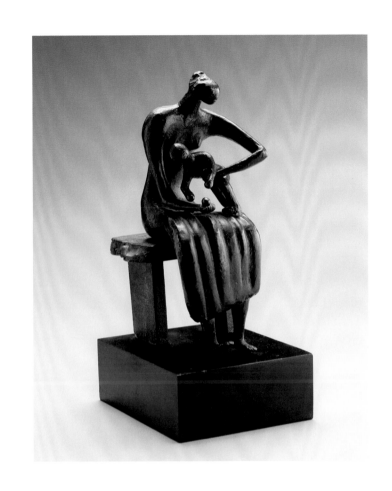

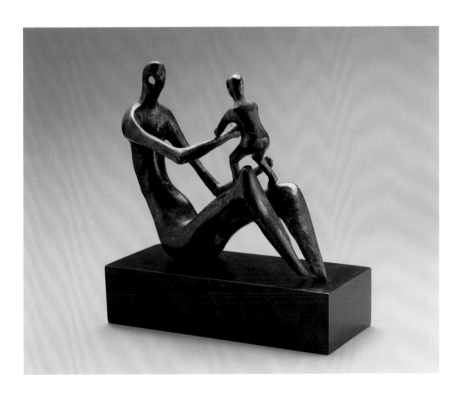

PABLO PICASSO

The Jester
1905 (this cast 1950s)

In 1905 Picasso moved away from the maudlin pathos that had marked his previous depictions of spiritually and economically bereft victims of society and began to show, with a calm and melancholy tenderness, saltimbanques and other carnival performers whose marginal lives gave them a certain resilient dignity. The sculpture now known as *The Jester,* one of a small group of modeled pieces Picasso sold to the dealer Ambroise Vollard that year, belongs to this transition. Certainly the piece has an affinity with several of Picasso's contemporary paintings and drawings of youthful harlequins. Yet Picasso's mistress at the time remembered it as "the bust of a madman," which could connect it with his other, earlier imagery of aged, emaciated beggars mockingly crowned. Apparently it passed through several stages of conception before arriving at its present bearing of stoic impassivity. According to Roland Penrose (who does not cite his source), the piece began as a bust of Picasso's friend the poet Max Jacob, initiated on an evening when the two had returned from a circus performance, but it was then progressively transformed into a more generic motif with only a partial resemblance.

The artistic inspiration for the piece is easier to pin down with certainty. As with other heads Picasso modeled at this time, *The Jester* reflects the strong influence of Auguste Rodin, then the aging lion of French sculpture. However, while Picasso mimed the way Rodin's painterly modeling breaks up the passage of light across bronze surfaces, he adopted none of the extreme muscularity and violent motion, nor any of the fragmentation of form and deeply gouged volumes, which made Rodin's sculpture so challenging. Tremulously subtle and active in surface detail, the modeling is thus relatively staid and inexpressive in the posture and volumes—until it reaches the floppy crown, whose jagged open silhouette and abstract agitation might be seen to prefigure Picasso's interest in breaking open sculpture's confines in a more dramatic fashion.

K.V.

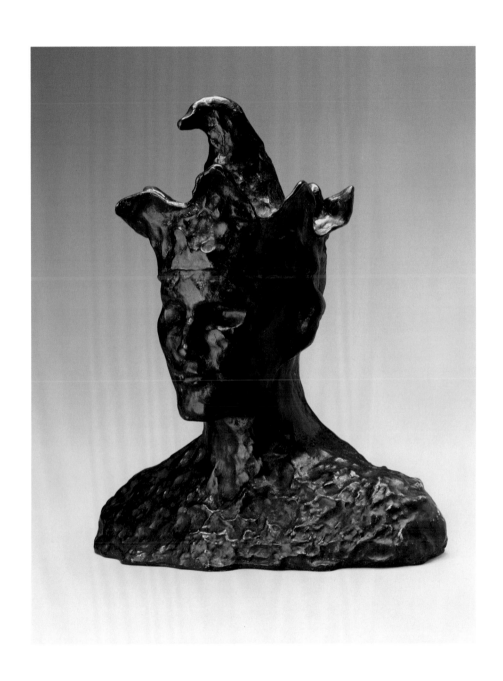

PABLO PICASSO

The Glass of Absinthe
1914

After a hiatus of more than two years dominated by Analytic Cubist painting, Picasso returned to sculpture with the planar construction *Guitar,* first made in cardboard in late 1912 and then refabricated in the sheet metal version in early 1913. Throughout the following year, he continued to experiment with relieflike structures based on cut-out and painted planes of cardboard, paper, and wood, which represented, in varying degrees of abstraction, still lifes of cafe and studio objects: musical instruments, newspapers, bottles, pipes, and glasses. In spring 1914, however, he was drawn back toward the idea he had seemingly abandoned with the Museum's unique *Woman's Head [Fernande]* of 1909, of a freestanding Cubist sculpture modeled in the round. In the interim, the idea had taken on several new layers of complexity.

The earlier *Head* was based on the conceit of opening up a solid volume by dissolving it into interpenetrating planes, but in *The Glass of Absinthe* he started with a colorless, transparent, and hollow form and then, perversely, rendered it in terms of solid shapes. Picasso complicated matters further by painting, on each of the six casts of the sculpture, different patterns of solid and pointillist color, which overlay and confound the relations of modeled form. Moreover, he played insistently here on the *trompe-l'esprit* interchange between simulacra, abstraction, and direct one-to-one identity that had marked the relationship between his collages and their tabletop subjects. He gave the surrogate glass the same scale and volumetric presence as its model, and left the foot as solid and functional as on the genuine vessel; then he pushed the uncertainties of the mix to an extreme by inserting an actual strainer beneath the ersatz sugar cube at the top of the composition.

The Glass of Absinthe bristles with connections to its time. Pictorially, the overpainting of pointillist "confetti" connects it to the numerous paintings and collages in which both Picasso and Braque deployed such arrays of dots as codes for atmosphere, as satiric jabs at Neo-Impressionism, and for their decorative appeal. Conceptually, the opening-up of the glass volume recalls the Futurist Umberto Boccioni's contemporaneous sculpture *Development of a Bottle in Space,* though in this more playful piece Picasso shows little interest in the dynamic swirl of forces that melded Boccioni's bottle form into its surrounding environment. In similar fashion, the inclusion of the strainer parallels Marcel Duchamp's idea of "ready-made" sculptures (e.g., his *Bicycle Wheel* of 1913), while neither owing to Duchamp nor participating in the spirit of his enterprise. And thematically, as Brooks Adams has pointed out, this monument to absinthe has a retrospective, valedictory air, both in reference to Picasso's bohemian cafe days and to the potent drink itself, the sale of which—after an epoch of controversy regarding its deleterious effects on the nation's health—was banned by the French legislature in this very year.

K.V.

PABLO PICASSO

Pregnant Woman
1950 (this cast 1955)

After World War II, Picasso began a new series of sculptures, often comical, that combined modeling with assemblages of scrap material such as toy cars, palm fronds, discarded wheels, and pipe segments. The principal catalysts for *Pregnant Woman* were shards of clay water jugs, retrieved from a refuse dump and used to cast the figure's breasts and swollen abdomen. With the smooth polish of these parts standing out against the rough remainder of the body, the figure becomes an updated fetish of fertility: the head as the only detached ovoid and as locus of thought is emphatically rhymed with the purer and more dominant shapes of the milk-giving and fetus-bearing parts of the body, while the rest of the anatomy seems to exist only as a schematic support, archaically stiff and sketchily modeled in contrast to the gravid volumes of the mammaries and uterus.

As often in Picasso's work, however, the statement of a seemingly universal theme may have had a topical and private meaning as well. By 1950, the liaison of Françoise Gilot and Picasso had already produced two children, but Picasso was apparently eager for a third. Gilot, who remembers that her weakness from the previous pregnancies made her reluctant to start again, has speculated that Picasso made *Pregnant Woman* both from memory of her appearance in the previous years and as a totem of what he hoped would come to pass.

K.V.

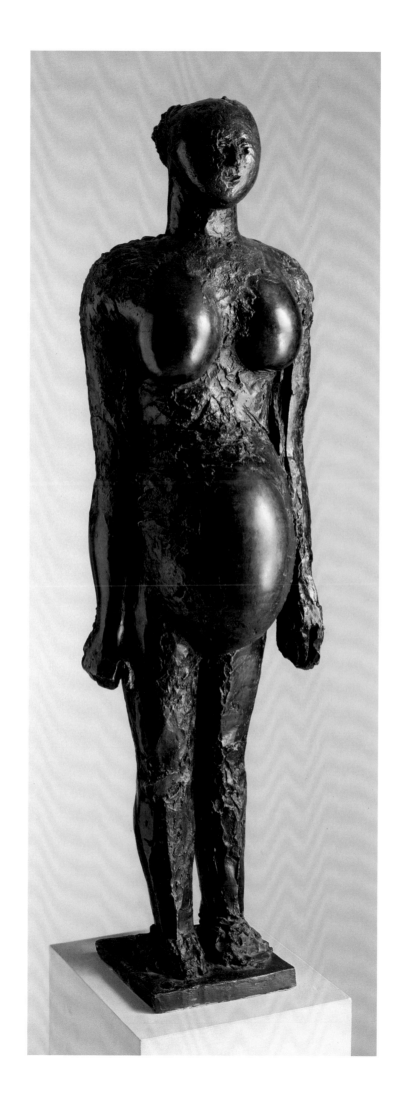

AUGUSTE RODIN
French, 1840–1917

Hand
c. 1884 (this cast 1950s?)

Crouching Woman
1890–91 (this cast 1958)

In the 1890s Rodin began exhibiting sculptures that were not simply incomplete in the conventional manner of portrait busts, but obviously fragmentary, lacking heads or arms or legs and bearing the marks of tearing or breakage. Visitors to his studio saw, moreover, the way he made new assemblage sculptures from seemingly disjunctive bits of past works.

Beginning at least with the isolated and upraised gestures of his first figures (*The Age of Bronze*, 1877, and *St. John the Baptist*, 1879), and especially after he started his long labors on the six *Burghers of Calais* in 1884, the hand became a special focus of these restless explorations. Eventually, Rodin enlarged combinations of hands and even had them carved in marble as independent sculptures, with titles such as *The Cathedral* (so named for the ogive arch formed by intertwined male and female hands). Nonetheless, while academic painting and sculpture had an accepted repertoire of legible gestures that conveyed specific meanings, such certainty was exactly what Rodin wanted to get away from: in hands, as in every other fragment of the body, he studied unguarded, vague, or extreme movements and pursued an expressivity that was initially independent of meaning, to which he only later assigned (often shifting) titles. Hanging from cords in macabre lines or lying by the hundreds in drawers, Rodin's many hands offered him little blossoms of anger, surrender, indecision, and desire that could be grafted in endlessly mutating combinations to similarly various arms, torsos, legs, and facial studies—or simply remain as spasmodic moments isolated in permanent suggestibility. The poet Rainer Maria Rilke, who worked as Rodin's secretary for years, remarked that "hands are already a rather complicated organism, a delta into which much life has flowed from distant origins to bathe in the great stream of action."

The small *Crouching Woman* (elsewhere known as *Seated Torso*) was said by one of Rodin's biographers to be a study for the boldly spread-eagle, foot-grasping leap of *Iris, Messenger of the Gods*, a headless figure initially conceived around 1880 in connection with work on the *Monument to Victor Hugo*. The resemblance is tenuous, however, and the little piece—which typically was conceived without a notion of a fixed base and shows no certain relation to standard axes of standing or sitting—is similar to countless other studies of uncertain date that chart Rodin's constant, prolific generation of hand-size sculptures in complex poses of movement.

K.V.

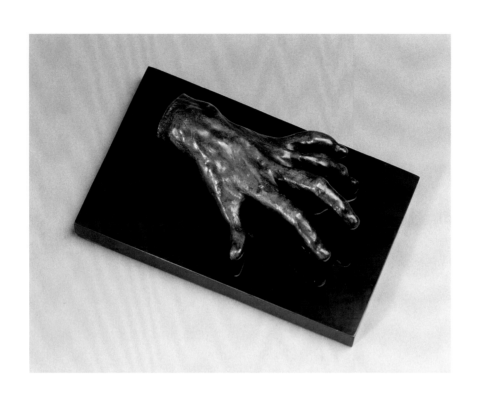

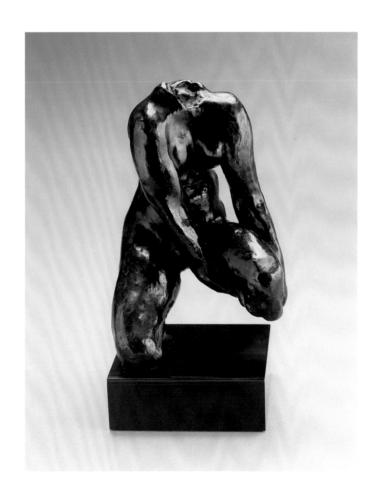

AUGUSTE RODIN

Hanako (Japanese Head)
c. 1908

EDWARD STEICHEN
American, born Luxembourg, 1879–1973

Hanako
1908

Rodin was constantly alert to forms of bodily expression which defied the norms of academic tradition, most typically in the arena of his models' natural, unposed movements, but also in the seemingly contrary area of highly stylized performances—as long as they were alien to the standard conventions of European culture. Like Gauguin, he became fascinated with "exotic" dancing when a troupe of Javanese performers appeared at the 1889 Paris World's Fair. This fascination continued in his later drawings of Cambodian dancers, who visited Paris in 1906, and extended into his admiration for unorthodox forms of modern dancing, from the can-cans of Montmartre cabarets to the performances of Isadora Duncan and Loïe Fuller. In the case of the Japanese actress Hanako, no less than fifty-three different heads and masks document Rodin's excitement and attention.

The sculptor met Hanako (the stage name of Hisako Hohta, 1868–1945) through Loïe Fuller. He was struck by the poses of her tiny, wiry frame, but even more so by the facial control which allowed her to "sculpt" her features into a wide range of expressive "masks" and then hold the gesture as if frozen. He set to work on a series of smaller-than-life-size masks and heads that showed a gamut of her performed moods, from composed serenity to stylized, ferocious, Kabuki-like exaggerations. While he worked, he invited the American photographer Edward Steichen, with whom we had been friendly for several years, to photograph the clay faces and heads.

Steichen was then frequently printing his negatives through a gum-bichromate process that allowed him to manipulate the print with a brush during its development. This yielded unique, painterly images, which he typically rephotographed and then printed in multiples from the new negative, using a gelatin-silver process without further manipulation. Mrs. Smith's photograph was made in this latter fashion. It shows how Steichen used a shallow focus in his original exposure and blurred the periphery of the gum-bichromate intermediary print to produce the arresting forward thrust of Hanako's fierce grimace. The aggressive emotional proximity is unlike anything in Steichen's own portraiture of that period, and the effect of intense life is so successful that even on prolonged viewing one can still remain uncertain whether the model was Hanako herself, or—as was the case here—Rodin's still-moist clay.

K.V.

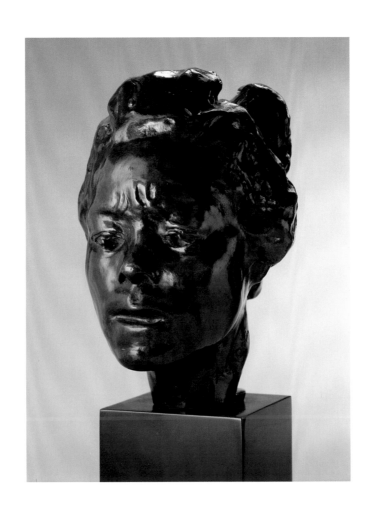

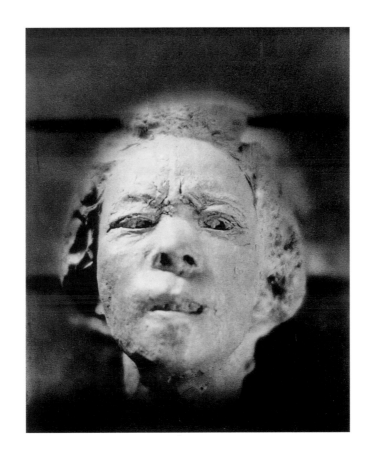

AUGUSTE RODIN

Nijinsky
c. 1912 (this cast 1958)

Despite the resemblance of the markedly Slavic features, some doubts have been raised as to whether this small figure actually depicts the Russian dancer Vaslav Nijinsky; it does not correspond to any of the movements for which Nijinksy was best known. Certainly Rodin was thrilled by Nijinsky's dancing, and almost as certainly he invited the new star—who had caused a sensation in Paris with his performance in *L'Après-midi d'une faune* in May of 1912—to his home in Meudon. We may be allowed to wonder, though, whether Nijinsky's wife did not embroider on the story she later told, which described Serge Diaghilev (the impresario of the Ballets Russes) arriving to find his prize dancer and the old sculptor propped against each other in a wine-induced afternoon sleep. Apparently suspecting Rodin of a homosexual seduction (somewhat unlikely for a seventy-one year old artist known for his passion for women), Diaghilev purportedly cut short the project of a larger sculpture and hustled his star away.

Ironically, Rodin had been at pains to dissociate himself from Nijinsky's own notorious "immorality." Though immediately after the debut he apparently encouraged his longtime friend Roger Marx to write on his behalf (and over his signature) a glowing letter to the press about Nijinsky's performance, he subsequently denied his authorship—apparently hoping not to be tainted by the scandal surrounding the sexual overtones of the Russian's dance at a time when the sculptor was seeking to persuade the government to create a Rodin Museum.

Still, though the identity may be less than firm and the public gesture was cowardly, there is nothing in the least hesitant or timid about this sculpture. The knobbily modeled knot of form suspended above an apparently nonsupporting leg (the figure's own arms seem to hoist the upper body aloft) retains the flashing speed of an extreme, almost spasmodic moment of exertion. Like many of the small dancing figures Rodin made late in his career, the figure forms an abstract cipher in space that will not stand of its own accord, and seems to leap away from earth as if some convulsing electric charge in the ground permitted no rest but only rebound and tumbling re-elevation. The violent counter-rotation of the right leg and head against the twist of torso and arms recalls Rodin's statement that he found again, concealed in the spontaneous movements his unposed models made, the deeper truth of the body language that had originally moved him in the work of Michelangelo.

K.V.

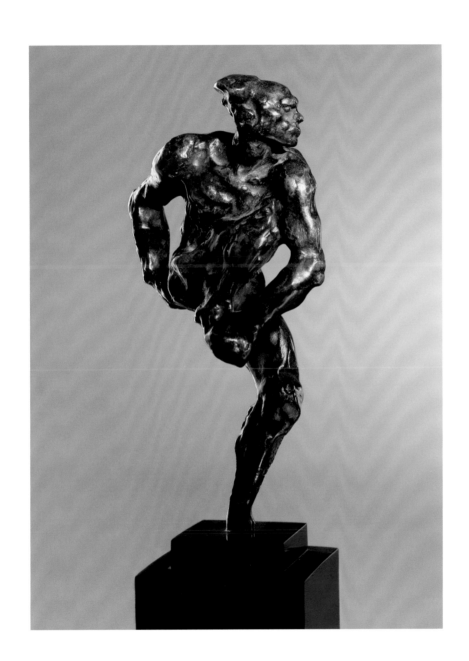

HILAIRE-GERMAIN-EDGAR DEGAS
French, 1834–1917

Green Landscape
c. 1890

A Wooded Landscape
c. 1890

From 1890 to 1892 Degas turned to landscape, executing a suite of some fifty monotypes that culminated in the first of just two one-man exhibitions during his lifetime. Although he had experimented intermittently with both the genre and the medium, the single-minded intensity and innovative approach of this later project distinguishes this body of work and establishes the series of monotypes as a distinctive component in an oeuvre otherwise dominated by urban figurative themes.

This suite of landscapes explores what Richard Kendall has termed the "speed and dislocation" that Degas experienced during a carriage trip through Burgundy in the early autumn of 1890. Executed in part when he stopped to rest in the village of Diénay at the home of a friend, the printmaker and artist Georges Jeanniot, these landscapes capture fleeting visions of unfamiliar scenery glimpsed from the door of Degas's carriage. As this excursion offered Degas freedom from the routine of his studio and a fresh vision of the country landscape, travel is crucial to them in both a conceptual and a practical sense.

Degas's landscape images, devoid of human presence and liberated from a recreational context, are more natural and yet more fantastic than their orthodox Impressionist counterparts. Unlike the carefree, shimmering Impressionist celebrations of the outdoors, Degas's suite of landscapes consists of quiet, even ghostly apparitions pulled forth from the recesses of his mind. Although born out of movement, these images ultimately convey a striking stillness. The vague, nearly abstract zones of color, evocative of Degas's then-failing eyesight, establish a melancholic calm and a hazy timelessness that is far removed from the documentary realism of his urban scenes. Necessarily executed away from the subject they portray, landscape monotypes require subjective embellishment, since remembered, rather than observed, reality must guide the artist. For Degas, ever caustic about the *plein air* practices of his Impressionist contemporaries, the distance implicit in this method better suited his creation of what he termed "imaginary landscapes." Furthermore, because the ink or oil medium on the monotype plate remains pliant until printed, it affords the artist complete spontaneity; in *Green Landscape* and *A Wooded Landscape* traces of Degas's fingerprints and brushstrokes are visible in the texture of the monotype, revealing the immediacy of the work and the urgency of his conjurings.

K.R.

66

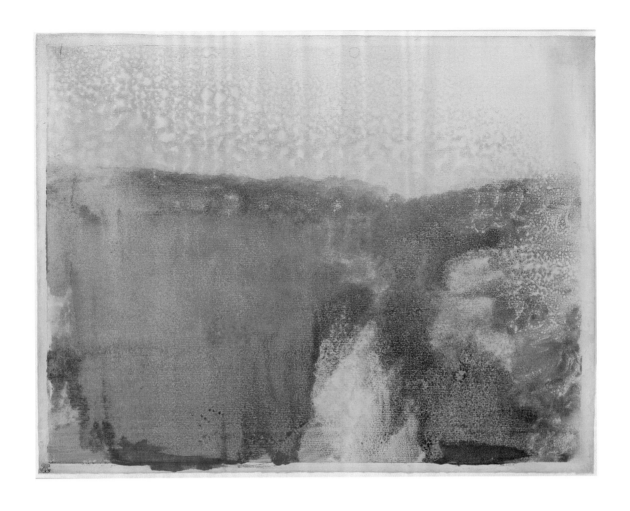

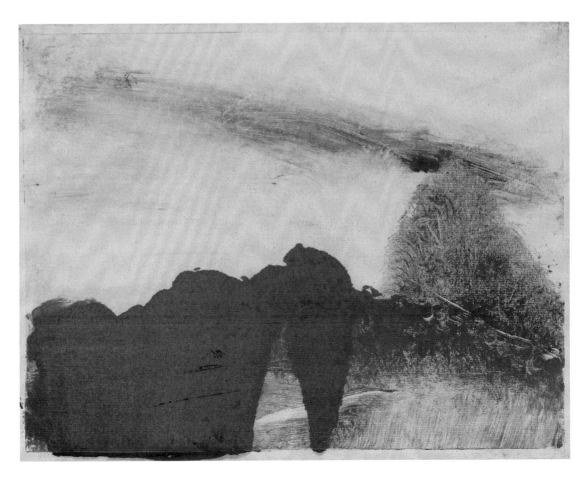

VASILY KANDINSKY

Improvisation
c. 1914

In December 1911 Kandinsky's seminal pre–World War I treatise *On the Spiritual in Art*, which summarized the philosophical and pictorial ideas of his first decade of artistic activity, was published in Munich. In its conclusion Kandinsky identified three categories of his pictures: Impressions, Improvisations, and Compositions; Improvisations were "chiefly unconscious, for the most part suddenly arising expressions of events of an inner character, hence impressions of 'internal nature.'" These pictures translated the artist's emotional responses to visual and conceptual stimuli into pictorial compositions.

Kandinsky painted thirty-six canvases called *Improvisation* (most were numbered consecutively, from one through thirty-five, though there are instances of duplicate or skipped numbers) as well as a number of watercolor studies. These works treat such allusive and mysterious themes as Paradise, Battle at Sea, Destruction, and Apocalypse. Although his definition of an Improvisation was only formally articulated in 1911, Kandinsky had already begun to use the term in his work in 1909, possibly at the inception of *On the Spiritual in Art*. Despite the sense of spontaneity implied by their name and free execution, many of the Improvisations were preceded by studies in watercolor.

This watercolor is an exceptionally dynamic, vibrant, and lyrical composition of amorphous shapes and patches of intense, bright colors. Although the forms apparently float freely in loose, unstructured space, they seem to orbit around the central motif. The translucent, brilliant colors, made more luminous by the white background that shines through from within, intensifies the atmospheric, abstract quality. Some of the forms seem to introduce veiled imagery from the artist's earlier works (such as *Composition VII*, 1913, Tretyakov Gallery, Moscow): a rowboat in the upper right, a sunlike shape in the upper left, and two overlapping ovals in the center (representing a reclining couple, based on the artist's Garden of Love motif) are visual clues that enable the spectator to create a narrative interpretation of this essentially abstract work.

Usually dated 1915, this watercolor has been redated to c. 1914. Although recorded in his Handlists between two works of 1913, it resembles most closely the painting *Improvisation with Cold Forms* of February 1914 (Tretyakov Gallery, Moscow). At that period Kandinsky painted a small group of abstract watercolors—a genre he would favor in 1915.

M.D.

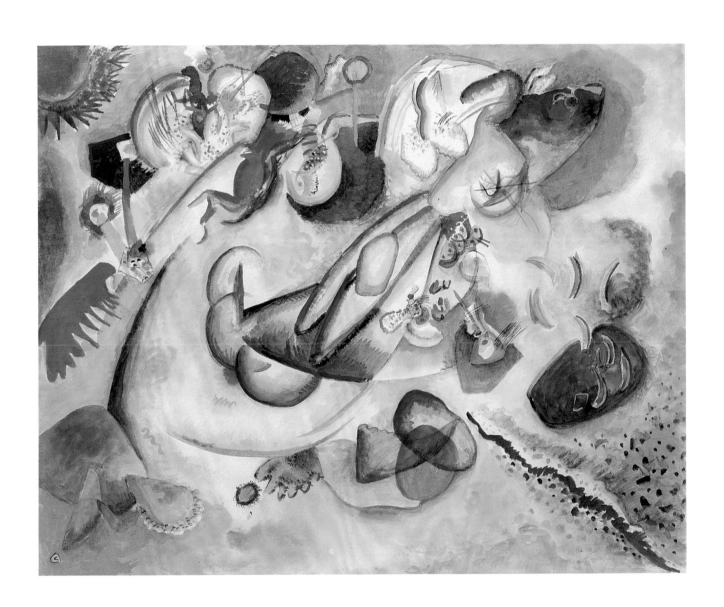

PABLO PICASSO

Meditation (Contemplation)
1904

This large watercolor is one of the young Picasso's most romantic, immediate, and intimate self-images and one of his earliest treatments of a theme that would occupy him throughout his life: the sleeper observed. In its internal contrast between the shadowy brooding of the artist and the luminous tenderness of his sleeping companion, the image also embodies transitions that were taking place in Picasso's life and art at the time.

In autumn 1904 Picasso was just beginning to leave behind the depressive pathos of his Blue Period paintings of beggars, blind men, and other suffering outcasts to begin the less lachrymose portrayals of actors and circus folk that would dominate the rose- and sand-toned paintings of the next year. His own new, clean-shaven look—recorded for perhaps the first time in this image—coincided with this shift away from a downbeat bohemianism. At the same time, he was entering into what would be his first long-term amorous liaison, with Fernande Olivier. Scholars have generally concurred that the sleeping figure here represents Fernande and have paired the image with another contemporary watercolor, in which a gaunt and disheveled man stands with his hands jammed into his pockets and stares angrily down at the same sleeping woman. That other observer at the bed is thought to represent Fernande's estranged husband, a sculptor named Debienne, whom Picasso saw as a rival.

Picasso's previous relations with women had been a matter chiefly of brief affairs and encounters with prostitutes. In the case of Fernande, however, he became possessive and eventually all but locked her into his Montmartre studio quarters to keep her at home. *Meditation* may result from that new *ménage*, or only announce in advance Picasso's desire for it. In any event, it charts his awareness of an altered balance of power between himself and his lover, and more broadly between two states of being. Leo Steinberg has suggested that Picasso's opposition of the shadowed thinker and the glowing dreamer contrasts the conflicted disturbances of consciousness with the seamless self-enclosure of sleep, making the woman an embodiment of mystery and desire in ways that transcend Eros, and vesting dominance in what appears to be defenseless vulnerability. As in other instances, Picasso here takes the stuff of well-worn stereotypes—man the thinker versus woman the dreamer, or masculinity as the seat of moral decision and femininity as the locus of passive, beautiful self-absorption—and models it into something sufficiently personal and complex to sustain lifelong exploration (see the later drawing and etching on a related theme, pp. 75, 77).

K.V.

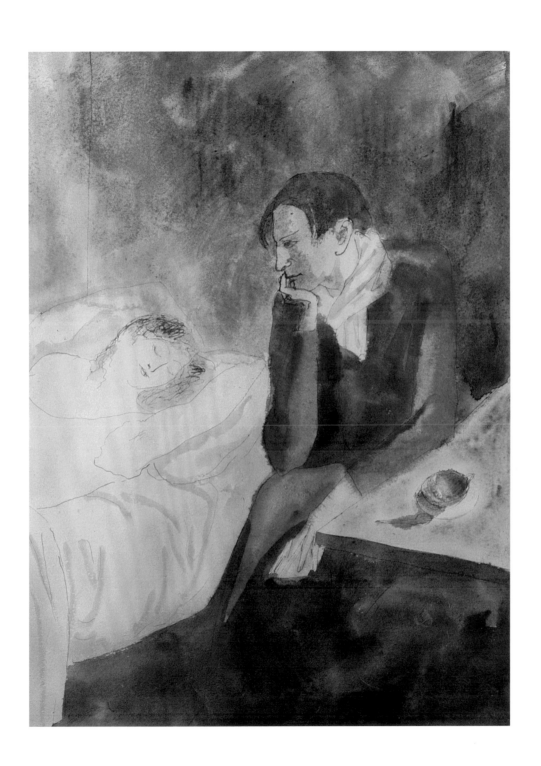

PABLO PICASSO

Nude Woman, Standing
1912

Individual Cubist drawings by Picasso have long been known, but only since the vast archives of the artist's own holdings became available have we been able to understand the true relation of such drawings to his paintings. As an independent drawing, *Nude Woman, Standing* is an object of considerable beauty; as a document in a chain of related images, it offers rich insights into the combination of spontaneity, systematic discipline, and open-ended experimentation through which Picasso and Braque invented and then constantly reinvented the generating "rules" of Cubism. As Pepe Karmel has shown in his doctoral dissertation on the subject (Institute of Fine Arts, New York University, 1993), Picasso worked at any given moment with an evolving vocabulary of shapes that he adapted and readapted to shifting representational tasks—so that a still life might well mutate into a figure, a body might be redrawn as a face, and a man with a guitar might become a woman with a violin, by the simple redirection or relocation of a set of curves, angles, or lines.

By studying the particular set of such conventions at play within Mrs. Smith's drawing, Karmel has been able to propose that its traditional date of 1911 is in error, and that the drawing is more properly situated in the summer of 1912. In particular, Karmel points to the odd "double convention" by which the breasts here are denoted both by relatively naturalistic curves and by dowel-like tubular projections. Those cylinders may reflect Picasso's attention to the similar protrusions by which the eyes were represented in an African (Grebo) mask he owned—eyes that would by autumn become an influence on the shaping of Picasso's *Guitar* construction. Other drawings with similar motifs, clearly datable to this summer's work, help reinforce that association.

While Mrs. Smith's drawing bears numerous further connections to Picasso drawings of the period, the latter are typically more schematic and purely linear. The rich shading of this piece is exceptional, but Karmel believes that Picasso most frequently selected just such highly finished Cubist drawings—usually in a larger format—as items of commerce for collectors.

K.V.

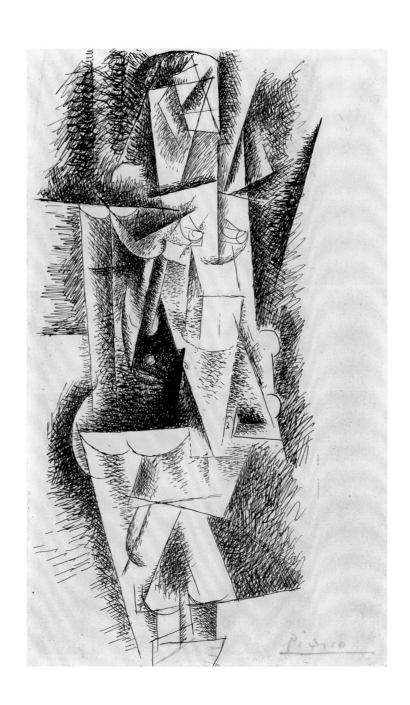

PABLO PICASSO

The Balcony
1933

The theme of the sleepwatcher, as we have seen in *Meditation* (p. 71), appeared early in Picasso's career and recurred throughout it. It was taken up with particular frequency and intensity, though, in the early 1930s, during the most ardent phase of Picasso's relationship with Marie-Thérèse Walter. Three decades younger than Picasso and apparently distractedly dreamy and passive by nature, Marie-Thérèse is typically pictured in these years in voluptuous, fruitlike forms (see, for example, the Museum's *Girl before a Mirror* of 1932), and is often shown in recumbent reverie.

As Leo Steinberg has discussed, Picasso had inherited the motif of the drowsing female nude observed by an intruding male from older art, where it traditionally pitted vulnerable (and so all the more arousing) beauty against predatory lust. In this moonlit scene however, the smooth-cheeked ephebe who scales the garden wall seems both timid and avid in his voyeurism, while it is the sleeper—recognizably a surrogate of Marie-Thérèse—who appears to writhe in the grasp of passionate fantasy. With his elongated body climbing by beautifully rhythmic and fluid contours to an outsized head, the spying youth is like some erotropic vine, while the focus of his gaze is convulsed into a seemingly limbless knot of swellings, protuberances, and tumescence. The drawing was done in August on the French Riviera, and the classical profile and architecture all conform to Picasso's contemporary evocations of an ideal Mediterranean world. There are also more mundane and topical suggestions of sultry nights, however, in the mosquito-net canopy covering the bed on the veranda, which seems to serve as a secondary moon, spotlighting—if not incubating—the drama of the dreamer below.

K.V.

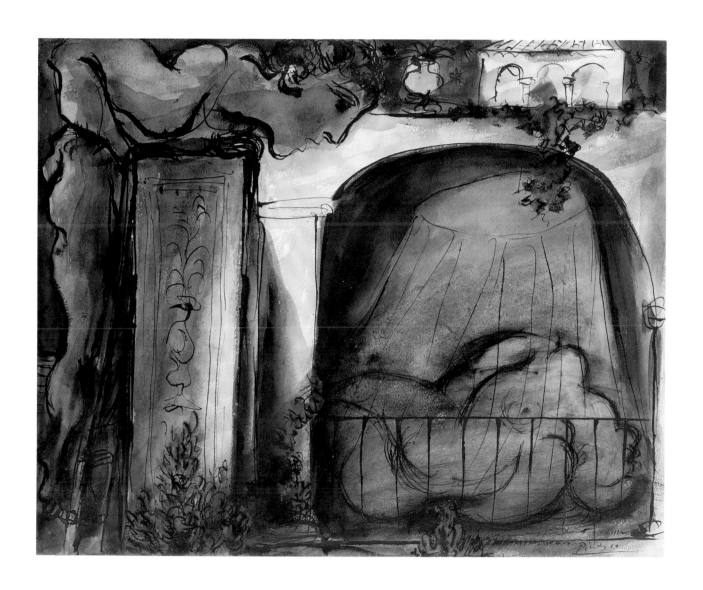

PABLO PICASSO

Faun Unveiling a Woman
1936

This image, one of the most celebrated in Picasso's body of prints, belongs to the series of etchings known as the Vollard Suite, which he produced in 1936. With the drawings *Meditation* of 1904 (p. 71) and *The Balcony* of 1933 (p. 75), it completes a triad of Picassos in Mrs. Smith's collection that show the encounter of a male observer with a sleeping woman—a favorite theme of the artist. *Meditation* is the most immediately personal of these scenes, and *The Balcony* the most charmingly romantic, but *Faun Unveiling a Woman* has a greater air of solemn seriousness and a more dramatic pictorial complexity than either.

It is uncertain whether the late afternoon sun or a brilliant full moon throws the slanting light that bisects this theatrical, boxlike space, but its effect is that, as in *Meditation,* the sleeper's body glows as a zone of fascination in a darkened room. Here only the erotic zone from breasts to thighs is illuminated, leaving the rest in shadow. The intruding faun unveils this mystery to the light and reaches forward to touch one breast with what seems a kneeling reverence and an archaic, ritual formality to his profiled gesture. In this mythic aspect, and in the play of chiaroscuro as well, some have seen a link to Rembrandt's etching of Jupiter and Antiope.

By 1936, Picasso's passionate relation with the much younger Marie-Thérèse Walter had begun to cool, and his awareness of the gaps between them may have become more focused. Throughout the images of seaside idylls in the Vollard Suite, the major male figure—often an artist, and almost certainly a surrogate for Picasso—is shown as hirsute and mature, in contrast to the youthful females. At other times, such as here, the protagonist is a hybrid beast, still more grizzled in contrast to the serene purity of the nude woman. In relation to another image in the Vollard Suite, of a woman observed by a Minotaur, Picasso explained to Françoise Gilot: "He is studying her, trying to read her thoughts, trying to decide whether she loves him *because* he is a monster." The faun at hand is, however, notably unmonstrous, stealing in on soft human feet rather than cloven hooves, and seemingly possessed of reticence and respect.

Picasso learned the printmaking method on which the beauty of the scene depends—sugar-lift aquatint, which allows for the variety of velvety, washlike shadows—from the master printmaker Roger Lacourière, whose father had invented it. He met Lacourière only in 1933, but swiftly learned through their collaboration to expand the power and subtlety of his prints. *Faun Unveiling a Woman* is one of the finest fruits of that apprenticeship.

K.V.

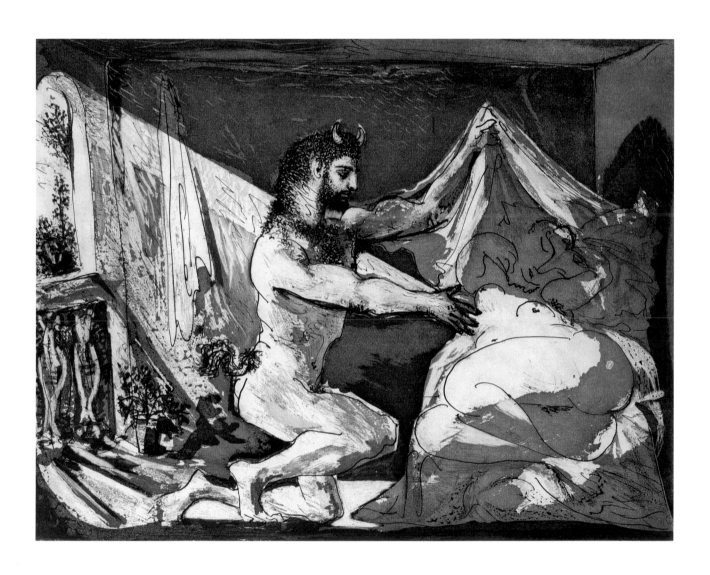

ODILON REDON

Imaginary Figure
1875–90

Like *Profile of Light* (p. 81), *Imaginary Figure* has an iconic quality and exudes a strange mysticism. The figure's bald head, cryptic gesture, and garment, which recalls the majesty of a Roman toga and the mystery of an occult robe, suggest his membership in a secret priesthood. Yet, unlike that work, the spirituality of *Imaginary Figure* is not clearly emblematic of good or evil, and the identity of the figure remains elusive. Though recognizably human, *Imaginary Figure* is one of the bizarre creatures that Odilon Redon describes in his writings about his work: "All my originality consists then of making improbable beings come to life humanly according to the laws of the probable . . . putting the logic of the visible at the service of the invisible."

The difficulty in associating *Imaginary Figure* definitively with any particular historical or cultural context further adds to its ambiguity and is characteristic of the charcoal and black chalk drawings Redon began creating in the 1870s, called *noirs* ("blacks") for their somber tenor and dark appearance. Redon himself called them "mes ombres" (literally "my shadows," but also implying "my shades," in the sense of ghosts or phantoms), and their haunted mood may reflect something of the artist's isolated childhood in the barren, marshy plains of the Médoc.

Just as Redon regarded himself as an *isolé,* outside the cultural mainstream, his *noirs* also existed in their own idiosyncratic context. They hark back to visions of premodern mythical culture and embody the dreamlike romanticisms of the avant-garde Symbolists who embraced them. It is precisely this disinherited quality that Redon cultivated so that his *noirs,* at once enigmatic and allusive, would act as mysterious vehicles of fantastic inspiration.

K.R.

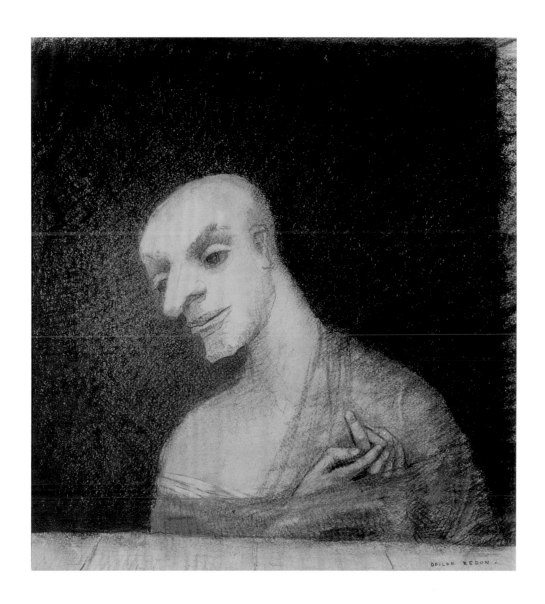

ODILON REDON

Profile of Light (The Fairy)
1882

During the heyday of Impressionist painting, Odilon Redon's *noirs* investigated the expressive power of black, the color his contemporaries most strove to exclude, and the nocturnal world of the psyche that their sunlight ignored. Through his *noirs,* Redon created domains of light and shadow not as nervously shifting fields of optical impressions, but as timeless symbolic realms of conflict between hope and menace. Hence, when Redon showed *Profile of Light* in 1882 (under its original title, *The Fairy*), its benevolent, vaguely religious luminosity stood out from a sequence of images of spiritual depravity that included *Faust and Mephistopheles, Angel and Demon,* and the grotesque *Satyr.* Later, in the final Impressionist exhibition (1886), he coupled this image—one of the many in which he turned to an idealized female profile as a symbol of truth and beauty—with the sinister *Primitive Man.* Anticipating aspects of the symbolism of Paul Gauguin and the Nabis, Redon sought to remake elements of traditional Catholic piety into weapons against the positivism of his age: while the idealized features and chaste demeanor of this disembodied head likely derive principally from early Renaissance paintings of the Virgin, the folkloric headdress may have a source in the accoutrements of rural religious ritual that would later draw Gauguin to Brittany.

K.R.

GEORGES-PIERRE SEURAT
French, 1859–1891

Covered Cart and a Dog
c. 1883

One of the principal tasks of modern art, in a generally secularized and disillusioned world, has been to reawaken us to the mystery and enchantment latent in the random facts of common experience. Seurat's drawings were among the first images to work this magic, and their enduring fascination shows that the trick is neither a simple one nor a dead end. When he began to form his style in drawings of the early 1880s, he knew precedents, of course, as in the still, lambent gaze that Vermeer had used to bless spare quotidian reality, but his translation of that fine-grained legacy into the reductive generalities of soft black crayon on coarsely nubbled white paper was an act of profound originality, deeply personal in manner and emotion. That vision, which intuited that the conditions of seeing and dreaming need not be antithetical, has continued to resonate in the spirit of artists as diverse as Giorgio de Chirico and James Turrell.

In the tradition of drawing Seurat inherited, line was held to be the probity of art, the reasoned mental architecture on which all nobility depended; in his paintings he often stressed the rhythmic interplay of contours. The drawings, however, conjure the world more frequently in terms of large, softly focused masses of light and dark. Here, in common with his contemporary Redon (see pp. 79, 81) but contrary to the Impressionists, he seems to have found more life in the shadow than in the sun.

Much seems excluded from this scene, where summary, muffled signs of a road, a dog, and a cart cloak in silence the locale, the time, the season, the colors, and the textures that must have informed the experience. Yet, contrarily and poetically, so much seems acutely observed in all its casual, aleatory conjunction: the odd tilt of the cart, the precise turn in the path, the sideways lean and alert ears of the animal. For many another artist, these facts might have been the matter of a sketchbook jotting. In Seurat's hands they become imposing and uncanny, absorbing us and imprinting themselves on our imagination like a scene from an unknown movie or a fragmentary memory of a place we have never been.

K.V.

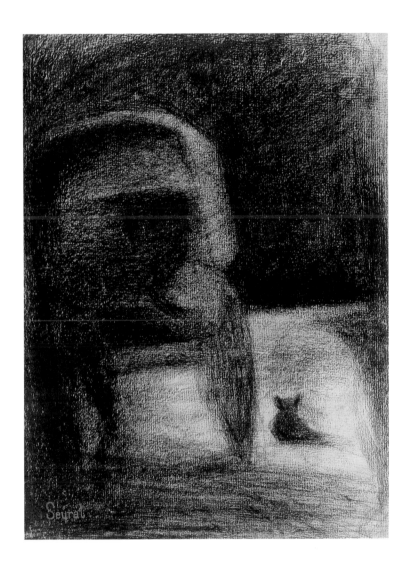

CATALOGUE

The order of the preceding plates and the following catalogue is alphabetical by artist's name within medium, with painting first, followed by sculpture, then prints and drawings. If there is more than one work by an artist in a medium, the objects are listed chronologically. The date assigned to a work is in accord with recent scholarship.

Unless otherwise noted, all works listed below are Collection of Louise Reinhardt Smith and are promised gifts to The Museum of Modern Art.

GEORGES BRAQUE
French, 1882–1963

The Table (Le Guéridon). (1921–22)

Oil and sand on canvas, 75 x 27¾ in. (190.5 x 70.5 cm).
Signed lower right: *G. Braque.* Not dated. The Metropolitan Museum of Art. Partial Gift of Mrs. Bertram Smith, in honor of William S. Lieberman, 1979. 1979.481.

PROVENANCE: Comte Etienne de Beaumont, Paris; Prince A. Pontiatowski, Paris; Knoedler & Co., New York.

EXHIBITIONS: Paris, *Salon d'Automne*, Nov. 1922; New York, Perls Galleries, *Georges Braque—An American Tribute: The Twenties*, 1964, no. 7; The Art Institute of Chicago, *Braque: The Great Years*, Oct. 7–Dec. 3, 1972, no. 35; New York, Solomon R. Guggenheim Museum, *Georges Braque*, June–Sept., 1988, no. 36.

REFERENCES: S. Fumet, *Georges Braque*, Paris, 1965, color repr. p. 79; D. Cooper, *Braque: The Great Years*, Chicago, 1972, pp. 57–58, repr. p. 57; N. Mangin, *Catalogue de l'oeuvre peint de Georges Braque. Peintures 1916–1923*, Paris, 1973, pp. 96–97, repr. p. 97; J. Leymarie, *Georges Braque*, New York, 1988, p. 100, no. 36.

ANDRÉ DERAIN
French, 1880–1954

Portrait of Lucien Gilbert. (1905)

Oil on canvas, 16⅛ x 12 in. (41 x 33 cm). Not signed or dated.

PROVENANCE: Alice Derain, Chambourcy, France; Galerie Maeght, Paris.

EXHIBITIONS: Paris, Musée National d'Art Moderne, *Derain*, Dec. 11, 1954–Jan. 30, 1955, no. 12; São Paulo, Museu de Arte Moderna, *III Bienal do Museu de Arte Moderna de São Paulo*, June–Oct., 1955, no. 3.

REFERENCES: G. Hilaire, *Derain*, Geneva, 1959, p. 69, no. 15; M. Kellermann, *André Derain: Catalogue raisonné de l'oeuvre peint*, vol. I: *1895–1914*, Paris, 1992, p. 232, no. 372; S. Pagé, *André Derain: Le Peintre du "trouble moderne,"* Paris, 1994, p. 130.

VASILY KANDINSKY
French, born Russia, 1866–1944

Picture with an Archer (The Bowman). (1909)

Oil on canvas, 69⅜ x 57⅞ in. (177 x 147 cm). Not signed or dated. The Museum of Modern Art, New York. Fractional gift of Louise Reinhardt Smith (the donor retaining a life interest in the remainder).

PROVENANCE: Christian Tetzen Lund, Copenhagen; Efraim Lundmark, Sweden; Svensk-Franska Konstgalleriet, Stockholm; Galerie Europe, Paris; Jacques Lindon, New York.

EXHIBITIONS: Darmstadt, *Deutscher Künstler Bund*, 1910; Hamburg, Kunstsalon Louis Bock, *Neue Künstler Vereinigung*, June, 1910; Odessa, Salon Izdebsky, *Salon 2 1910–11: International Art Exhibition*, Dec. 1910, no. 217; Berlin, Galerie der Sturm, *Kandinsky Kollektiv-Ausstellung 1902–1912*, Oct. 2–28, 1912, in 1st ed. of cat. as no. 42, in 2nd ed. as no. 39; Cologne, Kreis für Kunst Köln im Deutschen Theater, *Kandinsky-Ausstellung*, Jan. 30–Feb. 15, 1914, no. 39, traveled to Barmen (Wuppertal) and Aachen through late Mar.; The Hague, Kunstzalen d'Audretsch, *Zweite Ausstellung Den Haag/Holland: Expressionisten, Kubisten*, Mar. 17–Apr. 16, 1916, no. 26; New York, Solomon R. Guggenheim Museum, *Vasily Kandinsky, 1866–1944: A Retrospective Exhibition*, Jan. 25–Apr. 7, 1963, no. 11; New York, The Metropolitan Museum of Art, *Summer Loans*, July 17–Sept. 30, 1979.

REFERENCES: D. Ashton, "Kandinsky the Abstract Pioneer," *The New York Times*, Apr. 6, 1958, repr.; W. Grohmann, *Wassily Kandinsky: Life and Work*, New York, 1958, repr. p. 262; "Painting and Sculpture Acquisitions, January 1 through December 31, 1958," *The Museum of Modern Art Bulletin*, vol. XXVI, no. 4, 1959, p. 21, repr. p. 5; W. Grohmann, "La Grande unité d'une grande oeuvre," *XXᵉ siècle*, special issue: "Centenaire de Kandinsky," no. 27, Dec. 1966, repr. p. 11; H. K. Roethel in collaboration with J. K. Benjamin, *Kandinsky*, New York, 1979, pl. 8, color repr.; R.-C. Washton Long, *Kandinsky: The Development of an Abstract Style*, Oxford, 1980, pl. 23, repr.; H. K. Roethel and J. K. Benjamin, *Kandinsky: Catalogue Raisonné of the Oil-Paintings*, vol. I: *1900–1915*, Ithaca, 1982, color repr. p. 258; H. Duchting, *Wassily Kandinsky 1866–1944: Revolution der Malerei*, Cologne, 1993, color repr. p. 31.

HENRI-ÉMILE-BENOÎT MATISSE
French, 1869–1954

Landscape at Collioure. (Summer 1905)

Oil on canvas, 15⅜ x 18¼ in. (39 x 46.2 cm). Signed lower left: *Henri Matisse.* Not dated. The Museum of Modern Art, New York. Fractional gift of Louise Reinhardt Smith (the donor retaining a life interest in the remainder).

PROVENANCE: Sidney Janis Gallery, New York.

EXHIBITIONS: New York, The Museum of Modern Art, *"The Wild Beasts": Fauvism and Its Affinities*, Mar. 26–June 1, 1976; New York, The Museum of Modern Art, *Matisse in the Collection of The Museum of Modern*

Art, Oct. 25, 1978–Jan. 30, 1979; New York, The Metropolitan Museum of Art, *The Fauve Landscape*, Feb. 19–May 5, 1991, no. 183; New York, The Museum of Modern Art, *Henri Matisse: A Retrospective*, Sept. 24–Jan. 12, 1993, no. 52.

REFERENCES: J. Elderfield, *"The Wild Beasts": Fauvism and Its Affinities*, New York, 1976, color repr. p. 28; J. Elderfield, *Matisse in the Collection of The Museum of Modern Art*, New York, 1978, pp. 40–44, color repr. p. 41; P. Schneider, *Matisse*, New York, 1984, pp. 229, 388, color repr. p. 213; J. Flam, *Matisse: The Man and His Art, 1869–1918*, Ithaca, 1986, pp. 125, 151, color repr. p. 130, fig. 121; J. Flam, *Matisse: A Retrospective*, New York, 1988, color repr. p. 81; J. Freeman, *The Fauve Landscape*, New York, 1990, color repr. p. 182; J. Elderfield, *Henri Matisse: A Retrospective*, New York, 1992, pp. 133–34, color repr. p. 138, pl. 52.

HENRI-ÉMILE-BENOÎT MATISSE

Still Life with Aubergines. (Summer 1911)

Oil on canvas, 45¾ x 35⅛ in. (116.2 x 89.2 cm). Signed lower left: *Henri Matisse*. Not dated.

PROVENANCE: Galerie Bernheim-Jeune, Paris; Professor Oskar and Margarete Moll, Düsseldorf; Dr. Alfred Gold Collection, Berlin; Justin K. Thannhauser, Berlin then New York; Sale Parke-Bernet Galleries, New York, lot no. 660; Mr. and Mrs. Pierre Matisse; Mrs. Marcel Duchamp; Sidney Janis Gallery, New York.

EXHIBITIONS: Paris, *Salon d'Automne*, 1911, no. 679; London, Grafton Galleries, 1912, no. 33; Munich, Neue Kunst Hans Goltz, *Sommerschau*, Summer, 1914, no. 43; Berlin, Galerie Thannhauser, *Henri Matisse*, Feb.–Mar. 1930, no. 10; Paris, Galerie Georges Petit, *Henri Matisse*, June 16–July 25, 1931; Basel, Kunsthalle, *Henri Matisse*, Aug. 9–Sept. 15, 1931, no. 22; New York, Marie Harriman Gallery, *Les Fauves*, 1941, no. 6; Brussels, Palais des Beaux-Arts, *24 Oeuvres de Henri Matisse*, May, 1946; New York, Paul Rosenberg & Co., *Loan Exhibition of 21 Masterpieces by 7 Great Masters: Cézanne, Renoir, Degas, Van Gogh, Matisse, Braque, Picasso*, Nov. 15–Dec. 18, 1948, no. 13; New York, The Museum of Modern Art, *Works of Art Given or Promised and the Philip L. Goodman Collection*, Oct. 8–Nov. 9, 1958; New York, The Museum of Modern Art, *Henri Matisse: 64 Paintings*, 1966, no. 24; New York, The Museum of Modern Art, *Matisse in the Collection of The Museum of Modern Art*, Oct. 25, 1978–Jan. 30, 1979; New York, The Museum of Modern Art, *Henri Matisse: A Retrospective*, Sept. 16, 1992–Jan. 19, 1993, no. 184; Paris, Musée National d'Art Moderne, Centre Georges Pompidou, *Henri Matisse 1904–1917*, Feb. 25–June 21, 1993, no. 89.

REFERENCES: G. Apollinaire, "Le Salon d'Automne," *L'Intransigeant*, Oct. 12, 1911; G. Jean-Aubry, "Le Salon d'Automne: II^e article," *L'Art Moderne*, Oct. 22, 1911; A. Salmon, *Paris Journal*, Sept. 30, 1911; L. Vauxcelles, "Le Salon d'Automne," *Gil Blas*, Sept. 30, 1911; "L'Exposition Post-Impressioniste à la Grafton Gallery de Londres," *Gil Blas*, Oct. 4, 1912; *The Standard*, Oct. 7, 1912; C. Zervos, *Henri Matisse*, Paris, 1931 (painting shown in installation photo of Basel); A. H. Barr, Jr.,

Matisse: His Art and His Public, New York, 1951, pp. 153–54; G. Diehl, *Henri Matisse*, Paris, 1954, p. 60; *The Museum of Modern Art Bulletin*, vol. XXVI, no. 1, Fall 1958; D. Fourcade, "Rêver à trois aubergines," *Critique*, 1974, pp. 475–76, 480; D. Fourcade, *Matisse au Musée de Grenoble*, Grenoble, 1975, p. 38; J. Elderfield, *Matisse in the Collection of The Museum of Modern Art*, New York, 1978, pp. 82–84, color repr. p. 83; J. Flam, *Matisse: The Man and His Art*, Ithaca, 1986, pp. 306–07, 314, repr. p. 310, fig. 307; J. Elderfield, *Henri Matisse: A Retrospective*, p. 184, color repr. p. 217, pl. 144.

CLAUDE-OSCAR MONET

French, 1840–1926

Water Lilies with Reflection of a Willow Tree (Nymphéas, reflets de saule). (1916–19)

Oil on canvas, 51 x 79¼ in. (130 x 200 cm). Bottom left studio stamp. Not dated. The Metropolitan Museum of Art. Partial and Promised Gift of Mrs. Bertram Smith, 1983.

PROVENANCE: Michel Monet, Giverny (estate of the artist); Katia Granoff, Paris.

EXHIBITIONS: New York, The Metropolitan Museum of Art, *New Nineteenth-Century European Painting and Sculpture Galleries*, Sept. 20, 1993–Jan. 10, 1994.

REFERENCES: D. Ruart, J. D. Rey, and R. Maillard, *Nymphéas ou les miroirs du temps*, Paris, 1972, p. 188, repr. p. 188; The Metropolitan Museum of Art, New York, *Notable Acquisitions 1983–1984*, *The Metropolitan Museum of Art*, 1984, p. 67, repr. p. 67; D. Wildenstein, *Claude Monet: Biographie et catalogue raisonné*, vol. IV: *1899–1926, Peintures*, Geneva, 1985, p. 276, repr. p. 277, fig. 1858.

PABLO PICASSO

Spanish (died Mougins, France), 1881–1973

Bather. (Winter 1908–09)

Oil on canvas, 51¼ x 38⅛ in. (130 x 97 cm). Signed upper right: *Picasso*. Not dated.

PROVENANCE: Paul Rosenberg, Paris; Meric Gallery, Boulogne-sur-Seine; Carlo Frua de Angeli, Milan; Ernst Beyeler, Basel.

EXHIBITIONS: Milan, Palazzo Reale, *Pablo Picasso*, Sept. 23–Dec. 31, 1953, repr. pl. 13; Paris, Musée des Arts Décoratifs, *Picasso: Peintures 1900–1955*, June 6–Oct. 16, 1955, repr. no. 20; Munich, Haus der Kunst, *Picasso. 1900–1955*, Oct. 25–Dec. 18, 1955, no. 20, traveled to Cologne, Rheinisches Museum Köln-Deutz, Dec. 30, 1955–Feb. 29, 1956, and to Hamburg, Kunsthalle, Mar. 10–Apr. 29, 1956; Oslo, Kunstnernes Hus, *Picasso*, Nov. 1–Dec. 31, 1956, no. 34; London, Tate Gallery, *Picasso. Retrospective 1895–1959*, July 6–Sept. 18, 1960, no. 44, pl. 12b; New York, The Museum of Modern Art, *Picasso in the Collection of The Museum of*

Modern Art, Feb. 3–Apr. 2, 1972, no. 90; New York, The Museum of Modern Art, *Pablo Picasso: A Retrospective*, May 22–Sept. 16, 1980; New York, The Museum of Modern Art, *Picasso and Braque: Pioneering Cubism*, Sept. 24, 1989–Jan. 16, 1990.

REFERENCES: C. Zervos, *Histoire de l'art contemporain*, Paris, 1938, p. 203; C. Zervos, *Pablo Picasso*, vol. II-1: *Oeuvres de 1906 à 1912*, Paris, 1942, no. III; J. Merli, *Picasso: El Artista y la obra de nuestro tiempo*, Buenos Aires, 1948, pl. XI; M. Jardot, *Picasso 1900–1955*, Munich, 1955, p. 88, repr. p. 89; R. Penrose, *Picasso: His Life and Work*, London, 1958, p. 143, pl. VI, fig. 1; J. Golding, *Le Cubisme*, Paris, 1968, pl. 4b; W. Rubin, *Picasso in the Collection of The Museum of Modern Art*, New York, 1972, repr. p. 221; F. Minervino, *Tout l'oeuvre peint de Picasso: 1907–1916*, Milan, 1972, p. 97, no. 195; P. Daix and J. Rosselet, *Picasso, The Cubist Years 1907–1916: A Catalogue Raisonné of the Paintings and Related Works*, London, 1979, p. 235, no. 239; W. Rubin, *Pablo Picasso: A Retrospective*, New York, 1980, p. 89; *Pablo Picasso, 1909–1916: The Cubist Period*, Tokyo, 1981, color repr. no. 9; J. Palau i Fabre, *Picasso*, New York, 1985, no. 91; W. Rubin, *Picasso and Braque: Pioneering Cubism*, New York, 1989, color repr. p. 119; J. Palau i Fabre, *Picasso Cubism (1907–1917)*, New York, 1990, pp. 124–25, color repr. p. 124, no. 346; L. Zelevansky, ed., *Picasso and Braque: A Symposium*, New York, 1992, pp. 295–97, repr. p. 295, no. 7; J. L. Karmel, "Picasso's Laboratory: The Role of His Drawings in the Development of Cubism, 1910–1914," (diss. New York University, Institute of Fine Arts, 1993), pp. 43–47, repr. no. 19; C. P. Warncke, *Pablo Picasso 1881–1973*, vol. I: *The Works 1890–1936*, Cologne, 1994, color repr. p. 183.

PABLO PICASSO

Head of a Young Man. (Late) 1915

Oil on panel, 10¼ x 7⅛ in. (27 x 18.5 cm). Signed and dated bottom right: *Picasso/1915.*

PROVENANCE: Fine Arts Associates, New York.

EXHIBITIONS: New York, The Museum of Modern Art, *Picasso: 75th Anniversary Exhibition*, May 22–Sept. 8, 1957, repr. 47, traveled to The Art Institute of Chicago, Oct. 29–Dec. 8, 1957; Philadelphia Museum of Art, *Picasso: A Loan Exhibition of His Paintings, Drawings, Sculpture, Ceramics, Prints, and Illustrated Books*, Jan. 8–Feb. 23, 1958, cat. no. 78; London, Tate Gallery, *Picasso*, July 6–Sept. 18, 1960, no. 83, pl. 17d; New York, Duveen Brothers, Inc., *Picasso—An American Tribute: The Classical Phase*, Apr. 25–May 12, 1962, no. 3.

REFERENCES: C. Zervos, *Pablo Picasso*, vol. VI: *Supplément aux volumes I à V*, Paris, 1954, no. 1281; A. H. Barr, Jr., ed., *Picasso: 75th Anniversary Exhibition*, New York, 1957, repr. 47; P. Daix and J. Rosselet, *Picasso: The Cubist Years 1907–1916, A Catalogue Raisonné of the Paintings and Related Works*, London, 1979, p. 342, repr. p. 342, no. 813; J. Palau i Fabre, *Picasso Cubism (1907–1917)*, New York, 1990, pp. 428–29, repr. p. 429, no. 1276.

PABLO PICASSO

Woman Dressing Her Hair (Femme assise). (June 1940)

Oil on canvas, 51¼ x 38¼ in. (130 x 97 cm). Signed upper right: *Picasso.* Dated on back: *5-3. 1940* (with reference to an earlier painting begun on this canvas and then painted over).

PROVENANCE: Samuel M. Kootz Gallery, Inc., New York.

EXHIBITIONS: Milan, Palazzo Reale, *Pablo Picasso*, Sept. 23–Dec. 31, 1953, repr. p. 85; Paris, Musée des Arts Decoratifs, *Picasso: Peintures 1900–1955*, June 6–Oct. 16, 1955, no. 95; Munich, Haus der Kunst, *Picasso: 1900–1955*, Oct. 25–Dec. 18, 1955, no. 83, traveled to Cologne, Rheinishes Museum Köln-Deutz, Dec. 30, 1955–Feb. 29, 1956, and to Hamburg, Kunsthalle, Mar. 10–Apr. 29, 1956; New York, The Museum of Modern Art, *Picasso: 75th Anniversary Exhibition*, May 22–Sept. 8, 1957, traveled to The Art Institute of Chicago, Oct. 29–Dec. 8, 1957; Philadelphia Museum of Art, *Picasso: A Loan Exhibition of His Paintings, Drawings, Sculpture, Ceramics, Prints, and Illustrated Books*, Jan. 8–Feb. 23, 1958, cat. no. 205; New York, Staempfli Gallery, Inc., *Picasso—An American Tribute, The Forties*, Apr. 25–May 12, 1962, no. 1; The Cleveland Museum of Art, *Fifty Years of Modern Art 1916–1966*, June 15–July 31, 1966, no. 74; New York, The Museum of Modern Art, *Picasso in the Collection of The Museum of Modern Art*, Feb. 3–Apr. 12, 1972; New York, The Museum of Modern Art, *Pablo Picasso: A Retrospective*, May 22–Sept. 16, 1980, color repr., p. 366; New York, The Museum of Modern Art, *Art of the Forties*, Feb. 24–Apr. 30, 1991, p. 140, color repr. p. 35.

REFERENCES: C. Zervos, "Pour une nouvelle évaluation des valeurs esthétiques," pp. 9–19 in *Cahiers d'art 1940–1944*, nos. 15–19, repr. p. 12; A. H. Barr, Jr., *Picasso: Fifty Years of His Art*, New York, 1946, pp. 224–25, repr. p. 225; M. Jardot, *Picasso 1900–1955*, Munich, 1955, p. 220. repr. p. 221; A. H. Barr, Jr., ed., *Picasso: 75th Anniversary Exhibition*, New York, 1957, repr. p. 84; R. Penrose, *Picasso: His Life and His Work*, London, 1958, p. 296, pl. 19, no. 2; C. Zervos, *Pablo Picasso*, vol. X: *Oeuvres de 1939 et 1940*, Paris, 1959, no. 302; J. Berger, *The Success and Failure of Picasso*, New York, 1965, pp. 149–50; E. B. Henning, *Fifty Years of Modern Art 1916–1966*, Cleveland, 1966, pp. 80–81, color repr. p. 81; W. Rubin, *Picasso in the Collection of The Museum of Modern Art*, New York, 1972, pp. 8 (shown in photograph of Picasso), 158–59, 234, color repr. 159; L. Steinberg, "The Algerian Women and Picasso at Large" in *Other Criteria, Confrontations with Twentieth-Century Art*, Oxford, 1972, pp. 224–25, repr. p. 225; R. Penrose, "Beauty and the Monster" in R. Penrose and J. Golding eds., *Picasso 1881–1973*, London, 1973, color repr. p. 194, no. 325; M. M. Gedo, *Art as Autobiography*, Chicago, 1980, p. 193, repr. 195; W. Rubin, ed., *Pablo Picasso: A Retrospective*, New York, 1980, pp. 350–51, color repr. p. 366; *Pablo Picasso, 1931–1945: The Fantastic Period*, Tokyo, 1981, color repr. no. 57; J. Palau i Fabre, *Picasso*, New York, 1985, p. 19, no. 130; S. Hunter, "Picasso at War: Royan, 1940 Sketchbook No. 110, 1940" in A. Glimcher and M. Glimcher, eds., *Je Suis le Cahier, The Sketchbooks of Picasso*, New York, 1986, pp. 141–46, color repr. p. 141; P. Daix, *Picasso: Life and Art*, New York, 1987, pp. 135, 261–62; R. Castleman, ed., *Art of the Forties*, New York, 1991, p. 140, color repr. p. 35; J. Freeman, *Picasso and the Weeping Women, The Years of Marie-Thérèse Walter and Dora Maar*, Los Angeles, 1994, p. 190, color repr. p. 191; C. P. Warncke, *Pablo Picasso 1881–1973*, vol. II: *The Works 1937–1973*, Cologne, 1994, pp. 421, 430, color repr. p. 439.

PABLO PICASSO

Paloma Asleep. (Dec. 28, 1952)

Oil on wood panel, 44⅞ x 57½ in. (114 x 146 cm). Signed upper left: *Picasso.* Not dated.

PROVENANCE: Galerie Louise Leiris, Paris; Samuel M. Kootz Gallery, Inc., New York.

EXHIBITIONS: New York, The Museum of Modern Art, *Picasso: 75th Anniversary Exhibition*, May 22–Sept. 8, 1957, traveled to The Art Institute of Chicago, Oct. 29–Dec. 8, 1957; Philadelphia Museum of Art, *Picasso: A Loan Exhibition of His Paintings, Drawings, Sculpture, Ceramics, Prints, and Illustrated Books*, Jan. 8–Feb. 23, 1958, cat. no. 234; New York, The Museum of Modern Art, *Works of Art: Given or Promised and the Philip L. Goodwin Collection*, Oct. 8–Nov. 9, 1958; New York, The Museum of Modern Art, *Picasso in The Museum of Modern Art: 80th Birthday Exhibition*, May 15–Sept. 18, 1962; New York, The Museum of Modern Art, *Five Major Loans: Lent by Mrs. Bertram Smith and Norton Simon*, Aug. 30–Nov. 11, 1968; New York, Cordier-Warren Gallery, *Picasso—An American Tribute: The Fifties*, Apr. 25–May 12, 1962, no. 2; New York, The Museum of Modern Art, *Pablo Picasso: A Retrospective*, May 22–Sept. 16, 1980.

REFERENCES: A. H. Barr, Jr., "Portraits by Picasso," pp. 28–29, *The New York Times Magazine*, May 19, 1957, p. 29, repr. p. 29; A. H. Barr, Jr., ed., *Picasso: 75th Anniversary Exhibition*, New York, 1957, repr. p. 99; *The Museum of Modern Art Bulletin*, vol. XXVI, no. 1, Fall 1958, p. 41; A. H. Barr, Jr., *Works of Art: Given or Promised and the Philip L. Goodwin Collection*, New York, 1958, p. 41, repr. p. 41; Helen Kay, *Picasso's World of Children*, New York, 1961, repr. p. 174; C. Zervos, *Pablo Picasso*, vol. XV: *Oeuvres de 1946 à 1953*, Paris, 1965, no. 233; W. Rubin, ed., *Pablo Picasso: A Retrospective*, New York, 1980. p. 384, repr. p. 409; W. Spies, *Picasso's World of Children*, New York, 1994, p. 126, repr. p. 106.

ODILON REDON
French, 1840–1916

Green Death. (c. 1905)

Oil on canvas, 21⅜ x 18½ in. (56.7 x 47.6 cm). Signed lower left: *Odilon Redon.* Not dated.

PROVENANCE: Gustave Fayet, Arles; Léon Fayet, Arles; Galerie Les Tourettes, Basel.

EXHIBITIONS: Paris, Musée des Arts Decoratifs, *Odilon Redon (Rétrospective)*, 1926, no.19; Paris, Orangerie des Tuilleries, *Odilon Redon*, Oct. 1956–Jan. 1957, no. 164; Bern, Kunsthalle, *Odilon Redon*, Aug.–Oct. 1958, no. 177; New York, The Museum of Modern Art, *Art Nouveau: Art and Design at the Turn of the Century*, June 6–Sept. 6, 1960, traveled to Carnegie Institute, Pittsburgh, Oct. 13–Dec. 12, 1960, and to Los Angeles County Museum of Art, Apr. 1–May 15, 1961; New York, The Museum of Modern Art, *Odilon Redon, Gustave Moreau, Rodolphe Bresdin*, Dec. 4, 1961–Feb. 4, 1962, no. 41, traveled to The Art Institute of Chicago, Mar. 2–Apr. 25, 1962; Buenos Aires, Museo Nacional de Bellas Artes, *De Cézanne à Miró*, May 15–June 5, 1968, traveled to Santiago, Museo de Arte Contemporáneo de la Universidad de Chile, June 21–July 20, 1968, and to

Caracas, Museo de Bellas Artes, Aug. 5–20, 1968; New York, Acquavella Galleries, Inc., *Odilon Redon*, Oct. 22–Nov. 21, 1970, no. 19; New York, The Museum of Modern Art, *Modern Masters: Manet to Matisse*, Aug. 4–Sept. 1, 1975, traveled to Art Gallery of New South Wales, Sydney, Apr. 10–May 11, 1975, and to National Gallery of Victoria, Melbourne, May 28–June 22, 1975, no. 93.

REFERENCES: J. Rewald, *Odilon Redon, Gustave Moreau, Rodolphe Bresdin*, New York, 1962, color repr. p. 75; K. Berger, "Odilon Redon," in *Odilon Redon*, New York (Acquavella Galleries), 1970, p. 8, color repr. no. 19; W. S. Lieberman ed., *Modern Masters: Manet to Matisse*, New York, 1975, pp. 178–79, repr. p. 179; The National Museum of Art, Tokyo, "Odilon Redon," Mar. 17–May 7, 1989, pp. 123–24, fig. 5; S. F. Eisenman, *The Temptation of Saint Redon; Biography, Ideology and Style in the* Noirs *of Odilon Redon*, Chicago, 1992, p. 222.

JACQUES VILLON
French, 1875–1963

Portrait of the Artist. 1909

Oil on canvas, 15½ x 12½ in. (41 x 33 cm). Signed and dated lower left: *Jacques Villon 1909.*

PROVENANCE: Galerie Charpentier, Paris; Galerie Louis Carré & Cie, Paris; E. V. Thaw & Co., New York.

EXHIBITIONS: Paris, Galerie Charpentier, *Cent Tableaux de Jacques Villon*, Apr. 27–June 22, 1961, no. 3; New York, E. V. Thaw & Co., *Jacques Villon, Paintings 1909–1960*, Mar. 24–Apr. 18, 1964, no. 1; Cambridge, Mass., Fogg Art Museum, Harvard University, *Jacques Villon*, Jan. 17–Feb. 29, 1976, no. 21b.

REFERENCES: D. Vallier, "Intelligence de Jacques Villon," *Cahiers d'art*, Paris, 1955 (published 1956), repr. p. 63; D. Vallier, "Jacques Villon, oeuvres de 1897 à 1956," *Editions cahiers d'art*, Paris, 1957, repr. p. 39; R. Nacenta and J. Tardieu, "Cent Tableaux de Jacques Villon," Paris, 1961, repr.; M. N. Pradel, "La Maison cubiste en 1912," *Art de France*, no. 1, Paris, 1961, repr. p. 176; P. Cabanne, *The Brothers Duchamp*, Boston, 1976, repr. p. 57, p. 59; D. Robbins, ed., *Jacques Villon*, Cambridge, Mass., 1976, pp. 44–45, repr. p. 45.

MAURICE DE VLAMINCK
French, 1876–1958

Portrait of Solange (formerly *Portrait of Madeleine* or *Madeleine as a Child*). (1905)

Oil on canvas, 16 x 12½ in. (40.5 x 31.6 cm). Signed lower left: *Vlaminck.* Not dated.

PROVENANCE: Sidney Janis Gallery, New York.

EXHIBITIONS: New York, Perls Galleries, *Vlaminck (1876–1958), His Fauve Period (1903–1907)*, Apr. 9–May 11, 1968, no. 12.

REFERENCES: M. Sauvage, *Vlaminck: Sa Vie et son message*, Geneva, 1956, repr. p. 60.

ALBERTO GIACOMETTI

Swiss, 1901–1966, to Paris 1922

Hands Holding the Void (Invisible Object). (1934, this cast c. 1954–55)

Bronze, 60¼ x 12½ x 10 in. (154 x 32.4 x 28 cm). Signed back base: *Alberto Giacometti 1935 0/6.* Stamped back base: *Susse Fondeur, Paris.*

PROVENANCE: Pierre Matisse Gallery Corp., New York.

EXHIBITIONS: New York, The Museum of Modern Art, *Dada, Surrealism, and Their Heritage,* Mar. 27–June 9, 1968, fig. 163.

REFERENCES: W. Rubin, *Dada, Surrealism, and Their Heritage,* New York, 1968, p. 117, repr. p. 118; V. Fletcher, *Giacometti 1901–1966,* Washington, D.C., 1988, p. 105.

ARISTIDE MAILLOL

French, 1861–1944

Crouching Woman. (1930)

Bronze, 6½ x 9½ x 5 in. (16.5 x 24 x 12.8 cm). Stamped left at base: *Georges Rudier Fondeur Paris.* Stamped right at base: *3/6.* Stamped bottom: *M.*

PROVENANCE: Galerie Chalette, New York.

HENRI-ÉMILE-BENOÎT MATISSE

Standing Nude, Arms on Head. (1906, this cast 1951)

Bronze, 10⅜ x 4⅛ x 4⅞ in. (26.2 x 10.2 x 12.3 cm). Stamped on support for back left leg: *Henri Matisse/10.* Stamped on back left base: *Cire C. Valsuani Perdue.* Cast: 10/10.

PROVENANCE: Madame A. Matisse, Paris; Berggruen & Cie., Paris.

EXHIBITIONS: New York, The Museum of Modern Art, *The Sculpture of Matisse,* Feb. 23–May 1, 1972; New York, The Museum of Modern Art, *Matisse in the Collection of The Museum of Modern Art,* Oct. 25, 1978–Jan. 7, 1979, no. 25.

REFERENCES: A. Legg, *The Sculpture of Matisse,* New York, 1972, repr. p. 13; J. Elderfield, *Matisse in the Collection of The Museum of Modern Art,* New York, 1978, pp. 50–52. p. 183, repr. p. 51; C. Duthuit, *Henri Matisse, catalogue raisonné de l'oeuvre sculpté,* Paris, 1994, p. 50.

HENRY MOORE

British, 1898–1986

Mother and Child (No. 1). (1956)

Bronze, 6¾ x 5¾ x 5 ¾ in. (17.1 x 14.6 x 14.6 cm). Not signed or dated.

PROVENANCE: Ernest Brown & Phillips, Ltd.: The Leicester Galleries, London.

EXHIBITIONS: New York, The Metropolitan Museum of Art, *Henry Moore: 60 Years of His Art,* May 4–Sept. 25, 1983.

REFERENCES: A. Bowness, ed., *Henry Moore Sculpture and Drawings,* vol. III: *Sculpture 1955–64,* London, 1965, no. 406; W. Lieberman, *Henry Moore: 60 Years of His Art,* New York, 1983, p. 124, repr. p. 80.

HENRY MOORE

Mother and Child (No. 4). (1956)

Bronze, 6¾ x 6¾ x 5¾ in. (17.1 x 17.1 x 14.6 cm). Not signed or dated.

PROVENANCE: Ernest Brown & Phillips, Ltd.: The Leicester Galleries, London.

EXHIBITIONS: New York, The Metropolitan Museum of Art, *Henry Moore: 60 Years of His Art,* May 4–Sept. 25, 1983.

REFERENCES: A. Bowness, ed., *Henry Moore Sculpture and Drawings,* vol. III: *Sculpture 1955–64,* London, 1965, no. 409; W. Lieberman, *Henry Moore: 60 Years of His Art,* New York, 1983, p. 124.

PABLO PICASSO

The Jester. (1905, this cast 1950s)

Bronze, 15¾ x 13¾ x 8⅜ in. (40 x 35 x 22 cm). Signed rear bottom: *Piccasso [sic].* Not dated.

PROVENANCE: Berggruen & Cie., Paris.

EXHIBITIONS: New York, The Museum of Modern Art, *Picasso: 75th Anniversary Exhibition,* May 22–Sept. 8, 1957, traveled to The Art Institute of Chicago Oct. 29–Dec. 8, 1957; New York, The Museum of Modern Art, *The Sculpture of Picasso,* Oct. 11, 1967–Jan. 1, 1968, no. 5; New York, The Museum of Modern Art, *Pablo Picasso: A Retrospective,* May 22–Sept. 16, 1980.

REFERENCES: C. Zervos, *Pablo Picasso,* vol. I: *Oeuvres de 1895 à 1906,* Paris, 1932, no. 322; F. Olivier, *Picasso et ses amis,* Paris, 1933, p. 179; A. H. Barr, Jr., ed., *Picasso: 75th Anniversary Exhibition,* New York, 1957, repr. p. 26; R. Penrose, *Picasso: His Life and Work,* London, 1958, pp. 113–14, repr. no. 4, pl. 3; R. Penrose, *The Sculpture of Picasso,* New York, 1967, pp. 17, 26, repr. p. 52; W. Spies, *Sculpture by Picasso, with a Catalogue of the Works,* New York, 1971, pp. 17–18, 104; M. M. Gedo, *Art as Autobiography,* Chicago, 1980, p. 59; W. Rubin, ed., *Pablo Picasso: A Retrospective,* New York, 1980, p. 57, repr. p. 64; H. Seckel, *Max Jacob et Picasso,* Paris, 1994, p. 42.

PABLO PICASSO

The Glass of Absinthe. (Spring 1914)

Painted bronze with perforated absinthe spoon, 8½ x 6½ in. (21.6 x 16.5 cm), diameter at base 2½ in. (6.4 cm). Signed near base: *P* (in raised bronze). Not dated. The Museum of Modern Art, New York; Gift of Louise Reinhardt Smith.

PROVENANCE: Galerie Kahnweiler, Paris; Drouot sale, Paris; Fine Arts Associates, New York.

EXHIBITIONS: New York, Fine Arts Associates, *Rodin to Lipchitz, Part II*, Oct. 9–Nov. 3, 1956; New York, The Museum of Modern Art, *Recent European Acquisitions (Painting and Sculpture)*, Nov. 28, 1956–Jan. 20, 1957; New York, The Museum of Modern Art, *Picasso: 75th Anniversary Exhibition*, May 22–Sept. 8, 1957, traveled to The Art Institute of Chicago, Oct. 29–Dec. 8, 1957; New York, Otto Gerson Gallery, *Picasso—An American Tribute: Sculpture*, Apr. 25–May 12, 1962, no. 1; New York, The Museum of Modern Art, *Picasso in The Museum of Modern Art: 80th Birthday Exhibition*, May 15–Sept. 18, 1962; New York, The Museum of Modern Art, *The Sculpture of Picasso*, Oct. 11, 1967–Jan. 1, 1968, no. 18; Los Angeles County Museum of Art, *The Cubist Epoch*, Dec. 15, 1970–Feb. 21, 1971; The Museum of Modern Art, *Picasso in the Collection of The Museum of Modern Art*, Feb. 3–Apr. 2, 1972; New York, The Museum of Modern Art, *Pablo Picasso: A Retrospective*, May 22–Sept. 16, 1980; Saint Paul, France, Foundation Maeght, *Sculpture du XXᵉ siècle*, July 4–Oct. 4, 1981, no. 158; Madrid, Museo Español de Arte Contemporáneo, *Pablo Picasso 1881–1973: Exposición Antológica*, Nov. 5–Dec. 27, 1981, traveled to Museo Picasso, Barcelona, Jan. 11–Feb. 28, 1982; Berlin, National Galerie, *Picasso: Das Plastische Werk*, Oct. 7–Nov. 27, 1983, no. 36d, traveled to Kunsthalle Düsseldorf, Dec. 11, 1983–Jan. 29, 1984; New York, The Museum of Modern Art, *Picasso and Braque: Pioneering Cubism*, Sept. 24, 1989–Jan. 16, 1990; Basel, Kunstmuseum, *Picasso und Braque: Die Geburt des Kubismus*, Feb. 22–June 18, 1990; New York, The Museum of Modern Art, *High and Low: Modern Art and Popular Culture*, Oct. 7, 1990–Jan. 15, 1991, traveled to The Art Institute of Chicago, Feb. 20–May 12, 1991, and to Museum of Contemporary Art, Los Angeles, June 21–Sept. 15, 1991, no. 90; Basel, Kunstmuseum, *Transform: BildObjekt-Skulptur im 20 Jahrhundert*, June 14–Sept. 27, 1992.

REFERENCES: C. Zervos, *Pablo Picasso*, vol. II-2: *Oeuvres de 1912 à 1917*, Paris, 1942, no. 584; "Painting and Sculpture Acquisitions, July 1, 1955 through December 31, 1956," *The Museum of Modern Art Bulletin*, vol. XXIV, no. 4, Summer 1957, p. 38, no. 1326; A. H. Barr, Jr., ed., *Picasso: 75th Anniversary Exhibition*, New York, 1957, repr. p. 46; R. Penrose, *The Sculpture of Picasso*, New York, 1967, pp. 19–21, color repr. frontis.; D. Cooper, *The Cubist Epoch*, New York, 1971, color repr. p. 235, pl. 282; W. Spies, *Sculpture by Picasso, with a Catalogue of the Works*, New York, 1971, pp. 48–51, 98, 100, 142, 173, 221, 222, color repr. p. 49; W. Rubin, *Picasso in the Collection of The Museum of Modern Art*, New York, 1972, p. 95, color repr. p. 95; A. Bowness, "Picasso's Sculpture" in R. Penrose and J. Golding, eds., *Picasso 1881/1973*, 1973, pp. 132–33, color repr. p. 124, no. 200; P. Daix and J. Rosselet, *Picasso, The Cubist Years: 1907–1916, A Catalogue Raisonné of the Paintings and Related Works*, London, 1979, p. 332, repr. p. 332, no. 756; B. Adams, "Picasso's Absinthe Glasses: Six Drinks to the End of an Era," *Artforum*, Apr. 1980, pp. 29–32, color repr. p. 30; W. Rubin, ed., *Pablo Picasso: A Retrospective*, New York, 1980, p. 178, repr. p. 180; J. L. Prat, *Sculpture du XXᵉ siècle*, Paris, 1981, p. 3, repr. p. 182, no. 158; A. Beristan Diez and R. M. Subirana Torrent, *Pablo Picasso 1881–1973: Exposición Antológica*, Madrid, 1981, p. 170, color repr. p. 117; *Pablo Picasso, 1909–1916: The Cubist Period*, Tokyo, 1981, repr. no. 60; W. Spies, *Picasso: Das Plastische Werk*, Stuttgart, 1983, pp. 71–74, no. 36d; W. Rubin, *Picasso and Braque: Pioneering Cubism*, New York, 1989, color repr. p. 323; K. Varnedoe and A. Gopnik, *High and Low: Modern Art and Popular Culture*, New York, 1990, p. 279, color repr. p. 279, no. 90; L. Zelevansky, ed., *Picasso and Braque: A Symposium*, New York, 1992, p. 253, repr. p. 253; C. P. Warncke, *Pablo Picasso 1881–1973*, vol. I: *The Works 1881–1936*, Cologne, 1994, p. 228, color repr. p. 232.

PABLO PICASSO

Pregnant Woman. (1950, this cast 1955)

Bronze, 41¼ x 7⅞ x 6¼ in. (104.8 x 19.3 x 15.8 cm). Signed rear of base on top: *Cire C. Valsuani Perdue*. Not dated. Cast: 2/6. The Museum of Modern Art, New York; Gift of Louise Reinhardt Smith.

PROVENANCE: Galerie Louise Leiris, Paris.

EXHIBITIONS: New York, The Museum of Modern Art, *Recent European Acquisitions (Painting and Sculpture)*, Nov. 28, 1956–Jan. 20, 1957; New York, The Museum of Modern Art, *Picasso: 75th Anniversary Exhibition*, May 22–Sept. 8, 1957, traveled to The Art Institute of Chicago, Oct. 29–Dec. 8, 1957; Philadelphia Museum of Art, *Picasso: A Loan Exhibition of His Paintings, Drawings, Sculpture, Ceramics, Prints, and Illustrated Books*, Jan. 8–Feb. 23, 1958, cat. no. 34; New York, The Museum of Modern Art, *Picasso in The Museum of Modern Art: 80th Birthday Exhibition*, May 15–Sept. 18, 1962; Art Gallery of Toronto, *Picasso and Man*, Jan. 11–Feb. 16, 1964, traveled to Montreal Museum of Fine Arts, Feb. 28–Mar. 31, 1964; The Art Institute of Chicago, *Sculpture: A Generation of Innovation*, June 23–Aug. 27, 1967; New York, The Museum of Modern Art, *The Sculpture of Picasso*, Oct. 11, 1967–Jan. 1, 1968, no. 105; New York, The Museum of Modern Art, *Picasso in the Collection of The Museum of Modern Art*, Feb. 3–Apr. 12, 1972, no. 171; New York, The Museum of Modern Art, *Pablo Picasso: A Retrospective*, May 22–Sept. 16, 1980.

REFERENCES: "Painting and Sculpture Acquisitions, July 1, 1955 through December 31, 1956," *The Museum of Modern Art Bulletin*, vol. XXIV, no. 4, Summer 1957, p. 38, no. 330; A. H. Barr, Jr., ed., *Picasso: 75th Anniversary Exhibition*, New York, 1957, repr. p. 102; R. Penrose, *Picasso: His Life and Work*, London, 1958, p. 342, no. 5, pl. 24; F. Gilot and C. Lake, *Life with Picasso*, New York, 1964, p. 320; R. Penrose, *The Sculpture of Picasso*, New York, 1967, repr. p. 125; W. Spies, *Sculpture by Picasso, with a Catalogue of the Works*, New York, 1971, p. 174; W. Rubin, ed., *Pablo Picasso: A Retrospective*, New York, 1980, p. 382, repr. p. 399.

AUGUSTE RODIN

French, 1840–1917

Hand. (c. 1884, this cast 1950s?)

Bronze, 3½ x 5 in. (9.8 x 12.7 cm). Signed on left side of arm: *A. Rodin*. Stamped on wrist: *Alexis Rudier, Fondeur Paris*.

PROVENANCE: Peridot Gallery, New York.

AUGUSTE RODIN

Crouching Woman. (1890–91, this cast 1958)

Bronze, 5½ x 3½ x 3¼ in. (14 cm x 8.3 x 7.9 cm). Stamped under left leg: © *Musée Rodin 1958*. Stamped on left leg: *A. Rodin no/1* (?). Signed on left leg: *A. Rodin*. Stamped under right leg: *Georges Rudier. Fondeur. Paris*.

AUGUSTE RODIN

Hanako (Japanese Head). (c. 1908)

Bronze, 7 x 3¼ x 3½ in. (17.8 x 7.9 x 8.3 cm). Stamped back base: *Alexis Rudier. Fondeur. Paris*. Signed base: *A. Rodin*. Not dated.

PROVENANCE: Peridot Gallery, New York.

REFERENCES: J. L. Tancock, *The Sculpture of Auguste Rodin*, Philadelphia, 1976, p. 548.

AUGUSTE RODIN

Nijinsky. (c. 1912, this cast 1958)

Bronze, 7¼ x 2¼ x 3½ in. (18.1 x 5.4 x 8.3 cm). Stamped back left leg: ©. *Musée Rodin, 1958*. Signed side left leg: *A. Rodin no. 3*.

PROVENANCE: Galerie Gérald Cramer, Geneva.

REFERENCES: J. L. Tancock, *The Sculpture of Auguste Rodin*, Philadelphia, 1976, repr. p. 45.

HILAIRE-GERMAIN-EDGAR DEGAS
French, 1834–1917

Green Landscape. (c. 1890)

Monotype in oil colors on beige laid paper, 12¼ x 16¼ in. (30 x 40 cm). Not signed or dated. Collector's stamp lower left.

PROVENANCE: Marcel Guérin, Paris.

EXHIBITIONS: New York, The Metropolitan Museum of Art, *Degas Landscapes*, Jan. 21–Apr. 3, 1993, no. 48.

REFERENCES: J. Adhémar and F. Cachin, *Degas: The Complete Etchings, Lithographs, and Monotypes*, London, 1974, p. 280, no. 199; R. Kendall, *Degas Landscapes*, New York, 1993, pp. 158, 275, 306, color repr. p. 161.

HILAIRE-GERMAIN-EDGAR DEGAS

A Wooded Landscape. (c. 1890)

Monotype in emerald green, moss green, red-brown, and yellow oil colors on pale gray paper, 12¼ x 16¼ in. (29.9 x 40.3 cm). Not signed or dated.

PROVENANCE: Maurice Exteens, Paris; Paul Brame and César de Hauke, Paris; Sir Robert Abdy, London; Valentine Abdy, London; La Galerie de L'Oeil, Paris; E. V. Thaw and Co., New York.

EXHIBITIONS: Paris, *L'Oeil* Galerie de L'Art, *Degas: Paysages en monotype*, Sept. 1964; New York, E. V. Thaw and Co., *Nine Monotypes by Degas*, Dec. 1964; Cambridge, Mass., Fogg Art Museum, Harvard University, *Degas Monotypes, Essay, Catalogue, and Checklist*, Apr. 25–June 14, 1968, no. 297; New York, The Metropolitan Museum of Art, *The Painterly Print: Mono-*

types from the Seventeenth to the Twentieth Century, Oct. 16–Dec. 7, 1980, no. 34; New York, The Metropolitan Museum of Art, *Degas Landscapes*, Jan. 21–Apr. 3, 1993, no. 51.

REFERENCES: Denis Rouart, "Degas: Paysages en monotype," *L'Oeil*, no. 117, Sept. 1964, pp. 10–15, repr.; E. P. Janis, *Degas Monotypes: Essay, Catalogue, and Checklist*, Cambridge, Mass., 1968, pp. 73–74, repr. p. 74; J. Adhémar and F. Cachin, *Degas, The Complete Etchings, Lithographs, and Monotypes*, London, 1974, no. 187; C. Ives et al., *The Painterly Print: Monotypes from the Seventeenth to the Twentieth Century*, New York, 1980, p. 118, color repr. frontis., p. 119; R. Kendall, *Degas Landscapes*, New York, 1993, pp. 166, 273, 306, color repr. p. 166, no. 147.

VASILY KANDINSKY

Improvisation. (c. 1914)

Watercolor and gouache on paper, 14¾ x 18¼ in. (37.5 x 46.5 cm). Signed lower left: *K*. Not dated.

PROVENANCE: Nina Kandinsky, Paris; Heinz Berggruen, Paris; Marlborough-Gerson Gallery, New York; Fine Arts Associates, New York.

EXHIBITIONS: New York, The New Gallery, *Wassily Kandinsky: Paintings of 1905–1940*, Feb. 1–18, 1961, no. 7, repr.; New York, The Museum of Modern Art, *Kandinsky Watercolors*, Apr. 2–May 11, 1969, traveled to Fort Worth Art Center, July 13–Aug. 17, 1969, to Richmond, The Virginia Museum of Fine Arts, Sept. 1–Oct. 12, 1969, to Ithaca, N. Y., Cornell University, The White Museum of Art, Nov. 3–Dec. 14, 1969, to Louisville, Kentucky, The J. B. Speed Art Museum, Jan. 11–Feb. 22, 1970, to Manchester, N. H., The Currier Gallery of Art, Mar. 16–Apr. 27, 1970, to Toronto, Art Gallery of Ontario, May 23–June 28, 1970, no. 9, repr., to The Pasadena Art Museum, July 20–Aug. 31, 1970, to San Francisco Museum of Art, Sept. 21–Nov. 2, 1970, to Milwaukee Art Center, Jan. 21–Feb. 18, 1971, to Minneapolis Institute of Arts, Mar. 17–Apr. 25, 1971, and to Kunstmuseum Bern, May 27–July 18, 1971, no. 14.

REFERENCES: W. Grohmann, *Wassily Kandinsky: Life and Work*, New York, Harry N. Abrams, 1958, cc 698, repr. p. 407; V. E. Barnett, *Kandinsky Watercolours, Catalogue Raisonné*, vol. I: *1900–1921*, Ithaca, 1992, p. 346, repr. p. 346, no. 386; J. Hahl-Koch, *Kandinsky*, New York, 1993, color repr. p. 223.

PABLO PICASSO

Meditation (Contemplation). (Late 1904)

Watercolor and pen and ink on paper, 13⅜ x 10⅛ in. (31.8 x 19 cm). Signed lower right: *Picasso*. Not dated.

PROVENANCE: Raoul Pellequer, Paris; Wildenstein & Co., New York; Jules Furthman, New York; Vladimir Horowitz, New York.

EXHIBITIONS: New York, Jacques Seligmann & Co. Inc., *Picasso, Blue and Rose Periods*, Nov. 2–26, 1936, no. 18; New York, The Museum of Modern Art, *Picasso: 75th Anniversary Exhibition*, May 22–Sept. 8, 1957, traveled to The Art Institute of Chicago, Oct. 29–Dec. 8, 1957; Philadelphia Museum of Art, *Picasso: Loan Exhibition, of His Paintings, Drawings, Sculpture, Ceramics, Prints, and Illustrated Books*, Jan. 8–Feb. 23, 1958, no. 16; New

York, Knoedler & Co., *Picasso—An American Tribute: 1895–1909*, Apr. 25–May 12, 1962, no. 20; Toronto, The Art Gallery of Toronto, *Picasso and Man*, Jan. 11–Feb. 16, 1964, traveled to Montreal Museum of Fine Arts, Feb. 28–Mar. 31, 1964, no. 18; New York, The Museum of Modern Art, *Picasso in the Collection of The Museum of Modern Art,* Feb. 3–Apr. 12, 1972; New York, The Museum of Modern Art, *Pablo Picasso: A Retrospective*, May 22–Sept. 16, 1980.

REFERENCES: A. Level, *Picasso*, Paris, 1928, color frontis.; C. Zervos, *Pablo Picasso*, vol. I: *Oeuvres de 1895 à 1906*, Paris, 1932, no. 235; A. Cirici-Pellicer, *Picasso antes de Picasso*, Barcelona, 1946, no. 184; A. Cirici-Pellicer, *Picasso avant Picasso*, Geneva, 1950, no. 184; A. H. Barr, Jr., ed., *Picasso: 75th Anniversary Exhibition*, New York, 1957, repr. p. 23; R. Penrose, *Picasso, His Life and Work*, London, 1958, pl. III, no. 3; P. Daix, *Picasso, The Blue and Rose Periods, A Catalogue Raisonné of the Paintings, 1900–1906*, Neuchâtel, 1966, p. 245, no. XI.12, repr. p. 245; L. Steinberg, "Picasso's Sleepwatchers," in *Other Criteria, Confrontations with Twentieth-Century Art*, Oxford, 1972, pp. 93, 101, 105, repr. p. 92; W. Rubin, *Picasso in the Collection of The Museum of Modern Art*, New York, 1972, p. 30, color repr. p. 31; Michel Leiris, "The Artist and His Model," in R. Penrose and J. Golding, *Picasso 1881/1973*, London, 1973, p. 244, repr. p. 244, no. 395; P. Daix, *La Vie de peintre de Pablo Picasso*, Paris, 1977, p. 62; A. C. Costello, *Picasso's "Vollard Suite,"* New York, 1979, p. 167; M. M. Gedo, Picasso, *Art as Autobiography*, Chicago, 1980, p. 60, repr. p. 61; W. Rubin, ed., *Pablo Picasso: A Retrospective*, New York, 1980, p. 56, repr. p. 61; J. Palau i Fabre, *Picasso: The Early Years 1881–1907*, New York, 1981, pp. 390–91, color repr. p. 391, no. 1004; J. Palau i Fabre, *Picasso*, New York, 1985, color repr. no. 58; W. Spies, *Kontinent Picasso*, Munich, 1988, p. 106, repr. p. 113, no. 103; J. Richardson, *A Life of Picasso*, vol. I, New York, 1991, pp. 315, 325, repr. p. 316; C. P. Warncke, *Pablo Picasso 1881–1973*, vol. I: *The Works 1881–1936*, Cologne, 1994, p. 228, color repr. p. 112.

PABLO PICASSO

Nude Woman, Standing. (1912)

Pen and ink with traces of pencil on paper, 12½ x 7½ in. (31.8 x 19 cm). Signed lower right: *Picasso.* Not dated.

PROVENANCE: Daniel-Henry Kahnweiler, Paris; Justin K. Thannhauser, Berlin; Jawlenski, Berlin; Berggruen & Cie., Paris.

EXHIBITIONS: New York, The New Gallery, *Picasso, An American Tribute, Drawings*, Apr. 25–May 12, 1962, no. 15; New York, The Metropolitan Museum of Art, *The Cubist Epoch*, Apr. 19–June 6, 1971, no. 268; New York, The Museum of Modern Art, *Seurat to Matisse: Drawing in France, Selections from the Collection of The Museum of Modern Art*, June 13–Sept. 8, 1974, no. 140; New York, The Museum of Modern Art, *Pablo Picasso: A Retrospective*, May 22–Sept. 16, 1980; New York, The Museum of Modern Art, *The Modern Drawing: 100 Works on Paper from The Museum of Modern Art*, Oct. 26, 1983–Jan. 3, 1984; New York, The Museum of Modern Art, *Picasso and Braque: Pioneering Cubism*, Sept. 24, 1989–Jan. 16, 1990.

REFERENCES: D. Cooper, *The Cubist Epoch*, London, 1970, repr. p. 53, pl. 40; W. S. Lieberman, *Seurat to Matisse: Drawing in France, Selections from the Collection of The Museum of Modern Art*, New York, 1974, p. 100, repr. p. 41; C. Zervos, *Pablo Picasso*, vol. XXVIII: *Supplément aux années 1910–1913*, Paris, 1974, no. 38; W. Rubin, *Pablo Picasso: A Retrospective*, New York, 1980, repr. p. 147; J. Elderfield, *The Modern Drawing: 100 Works on Paper from The Museum of Modern Art*, New York, 1983, pp. 60–61, repr. p. 61; W. Rubin, *Picasso and Braque: Pioneering Cubism*, New York, 1989, repr. p. 241; J. Palau i Fabre, *Picasso Cubism (1907–1917)*, New York, 1990, p. 508, repr. p. 255, no. 702; C. P. Warncke, *Pablo Picasso 1881–1973*, vol. I: *The Works 1890–1936*, Cologne, 1994, repr. p. 196.

PABLO PICASSO

The Balcony. (Aug. 1, 1933)

Watercolor and ink on paper, 14¾ x 19⅞ in. (39.4 x 49.5 cm). Signed lower right: *Picasso*. Not dated.

PROVENANCE: Paul Rosenberg & Co., Paris.

EXHIBITIONS: New York, The Museum of Modern Art, *Picasso: 75th Anniversary Exhibition*, May 22–Sept. 8, 1957, traveled to The Art Institute of Chicago, Oct. 29–Dec. 8, 1957; Philadelphia Museum of Art, *Picasso: A Loan Exhibition of His Paintings, Drawings, Sculpture, Ceramics, Prints, and Illustrated Books*, Jan. 8–Feb. 23, 1958, cat. no. 234; New York, The New Gallery, *Picasso—An American Tribute: Drawings*, Apr. 25–May 12, 1962, no. 33.

REFERENCES: A. H. Barr, Jr., ed., *Picasso: 75th Anniversary Exhibition*, New York, 1957, repr. p. 72.

PABLO PICASSO

Faun Unveiling a Woman. (June 12, 1936)

Aquatint, 12½ x 16⅞ in. (31.7 x 41.7 cm). Not signed or dated.

REFERENCES: H. Bollinger, *Suite Vollard, Pablo Picasso*, Stuttgart, 1956, no. 27 (image from the same plate); G. Bloch, Pablo Picasso, *Catalogue de l'oeuvre gravé et lithographié 1904–1967*, Berne, 1968, repr. no. 230 (image from the same plate); L. Steinberg, "Picasso's Sleepwatchers" in *Other Criteria, Confrontations with Twentieth-Century Art*, Oxford, 1972, p. 102, repr. p. 103 (image from the same plate); A. C. Costello, *Picasso's "Vollard Suite,"* New York, 1979, pp. 173–76 (image from the same plate); H. Bollinger, *Picasso's Vollard Suite*, New York, 1985, pp. xiii, xvi, repr. p. 27 (image from the same plate).

ODILON REDON

Imaginary Figure. (1875–90)

Charcoal and black chalk on cream wove paper, 13½ x 12¹¹⁄₁₆ in. (34.3 x 32.2 cm). Signed lower right: *Odilon Redon*. Not dated.

PROVENANCE: Lucien Goldschmidt, Inc., New York.

ODILON REDON

Profile of Light (The Fairy). (1882)

Charcoal and black chalk on cream wove paper, 14½ x 10½ in. (36 x 26 cm). Signed lower right: *Odilon Redon*. Not dated.

PROVENANCE: Boussod et Valadon, Paris; Mr. X (possibly Edvard Brandès), Copenhagen; Donald M. D. Young, London; Cookham Dean Berks, London; Galerie Beyeler, Basel.

EXHIBITIONS: Paris, Telegraph Office of *Le Gaulois, Second Exhibition of Drawings of M. Odilon Redon,* Mar. 1882; Paris, 1 Rue Lafitte, *Eighth Group Exhibition of the Impressionists,* May 15–June 15, 1886; The Art Institute of Chicago, *Odilon Redon: Prince of Dreams 1840–1916,* July 2–Sept. 18, 1994, no. 71.

REFERENCES: G. Geffroy, "La Nuit," *La Justice,* Mar. 15, 1886; A. Mellerio, *Odilon Redon,* Paris (1913), reprint, 1968, p. 98; R. Bacou, *Odilon Redon: La Vie et l'oeuvre, point de vue de la critique au sujet de l'oeuvre,* Geneva, 1956, p. 71; S. F. Eisenman, *The Temptation of Saint Anthony: Biography, Ideology, and Style in the* Noirs of Odilon Redon, Chicago, 1992, p. 161, repr. p. 163, no. 123; A. Wildenstein, *Catalogue raisonné de l'oeuvre peint et dessiné,* vol. I, Paris, 1992, no. 267; D. Druick and P. K. Zegers, "In the Public Eye," in *Odilon Redon: Prince of Dreams 1840–1916,* Chicago, 1994, pp. 145, 160, 284, 440, repr. pp. 135, no. 13:3, 143, no. 29.

GEORGES-PIERRE SEURAT

French, 1859–1891

Covered Cart and a Dog. (c. 1883)

Conte crayon on paper, 12⁵⁄₁₆ x 9¼ in. (30.5 x 22.9 cm). "Moline" stamp in red, lower left: *Seurat.* Not dated.

PROVENANCE: (Probably) Madeleine Knoblock, Paris; Léonce Moline, Paris; Mme J. D.; Camille Platteel, Paris; Félix Fénéon, Paris; Mlle. Alix Guillain; Princess de Bassiano, Rome; Princess Marguerite Caetani, Rome; Mr. del Corso, Rome; Galerie dell'Obelisco, Rome; E. V. Thaw & Co., New York.

EXHIBITIONS: Paris, Galerie Lafitte, *Exposition de quelques peintures, aquarelles, dessins, et eaux-fortes de Ch. Agard, Eug. Delâtre, J. H. Lebasque, feu Georges Seurat,* Feb. 22–Mar. 14, 1895; Paris, Galerie Bernheim-Jeune, *Rétrospective Georges Seurat,* 1908–09, no. 145; Paris, Galerie Bernheim-Jeune, *Les Dessins de Seurat,* Nov. 29–Dec. 24, 1926, no. 67; Rome, Galerie dell'Obelisco, *Georges Seurat,* 1950, no. 9; The Art Institute of Chicago, *Seurat, Paintings and Drawings,* Jan. 16–Mar. 7, 1958, traveled to New York, The Museum of Modern Art, Mar. 24–May 11, 1958, no. 48; New York, The Museum of Modern Art, *Seurat to Matisse: Drawing in France, Selections from the Collection of The Museum of Modern Art,* June 13–Sept. 8, 1974, no. 158; New York, The Metropolitan Museum of Art, *Seurat: Drawings and Oil Sketches from New York Collections,* Sept. 29–Nov. 27, 1977, no. 15; New York, The Metropolitan Museum of Art, *Georges Seurat 1859–1891,* Sept. 24, 1991–Jan. 12, 1992, no. 70.

REFERENCES: G. Kahn, *Les Dessins de Seurat,* Paris, 1926, repr. pl. 52; P. Mabille, "Dessins inédits de Seurat," *Minotaure,* 1938, p. 3; D. C. Rich, ed., *Seurat, Paintings and Drawings,* Chicago, 1958, p. 28, repr. p. 51; C. M. de Hauke, *Seurat et son oeuvre,* Paris, 1961, no. 543, repr. p. 131; J. Russell, *Seurat,* New York, 1965, p. 63, repr. pl. 53; W. S. Lieberman, *Seurat to Matisse: Drawing in France, Selections from the Collection of The Museum of Modern Art,* New York, 1974, p. 16; J. Bean, *Seurat: Drawings and Oil Sketches from New York Collections,* New York, 1977, p. 5; R. Herbert, *Georges Seurat 1859–1891,* New York, 1991, p. 99, repr. p. 99.

EDWARD STEICHEN

American, born Luxembourg, 1879–1973

Hanako. (1908)

Gelatin silver print, 8¾ x 7¼ in. (22.2 x 18.4 cm). Not signed or dated.

PROVENANCE: Gift of the artist.

GIFTS AND PROMISED GIFTS OF LOUISE REINHARDT SMITH TO THE MUSEUM OF MODERN ART

Ivan Le Lorraine Albright. *Woman in Black.* (1975). Etching, printed in dark gray-brown.★★★

Armand P. Arman, *Black Toothbrushes.* 1972. Charcoal and spray paint on paper.★

Armand P. Arman, *Technical Lace.* 1972. Pen and ink on paper.★

Umetaro Azechi. *Remains of a Volcano.* 1952. Woodcut, printed in black, dark gray, medium gray, light brownish gray, strong brown, dark greenish blue, medium red-brown, and dark bluish gray. ★★★

Giacomo Balla. *Study for Streetlight (Lampada—studi di luce).* (1909). Pencil (recto). Pencil and red ink (verso).★★★

Leonard Baskin. *Beatitudes.* (1955). Wood engraving, printed in black, strong green, yellow, medium yellow, and medium green-blue.★★★

Leonard Baskin. *Bartleby in the Tombs.* 1961. Brush and ink and pencil on paper.★

William Baziotes. *Pompeii.* 1955. Oil on canvas.★★★

Jules Chéret. *Poster for Palais de Glace.* 1847. Color lithograph.★★★

Pierre Courtin. *Chant G.* 1953. Etching and engraving, printed in gray.★★★

Hilaire-Germain-Edgar Degas. *Green Landscape.* (c. 1890). Monotype in oil colors on beige laid paper.★★

Hilaire-Germain-Edgar Degas. *A Wooded Landscape.* (c. 1890). Monotype in emerald green, moss green, red-brown, and yellow oil colors on pale gray paper.★★

Hanne Darboven. *49 x 49 (7 x 7 = 49).* (1972). Graphite pencil on 49 sheets of lined paper.★

André Derain. *Portrait of Lucien Gilbert.* (1905). Oil on canvas.★★

Otto Dix. *Nelly I.* (1924). Drypoint printed in black.★★★

Jean Dubuffet. *Letter From El Goléa.* (1948). Pen and ink on paper.★

Öyvind Fahlström. *Notes for "The Little General."* (1968). Pen and ink, ballpoint pen, and pencil on paper.★★★

Öyvind Fahlström. *Notes 4 (C.I.A. Brand Bananas).* 1970. Synthetic polymer paint and pen and ink on paper.★★★

Öyvind Fahlström. *Plan for World Trade Monopoly.* 1970. Synthetic polymer paint, pen and ink, colored pencil, and pasted paper.★★★

Alberto Giacometti. *Hands Holding the Void (Invisible Object).* (1934, this cast c. 1954–55). Bronze.★★

Tomo Inagaki. *Pumpkins.* 1955. Woodcut, printed in color on paper.★★★

Vasily Kandinsky. *Picture with an Archer (The Bowman).* (1909). Oil on canvas.★

Vasily Kandinsky. *Improvisation.* (c. 1914). Watercolor and gouache on paper.★★

Sumio Kawakami. *Nambanesque Behavior.* (1955). Woodcut.★★★

Hide Kawanishi. *Interior with Narcissus.* (1947). Woodcut, printed in color.★★★

Ernst Ludwig Kirchner. *Martin.* (1918). Woodcut, printed in color.★★★

Jovan Kratohvil. *Fish.* 1955. Plaster cut, printed in color.★★★

Jennet Lam. Untitled. 1962. Watercolor and pen and ink on paper.★

Jennet Lam. Untitled. 1964. Watercolor and pencil on paper.★

Ger Lataster. *Summer Landscape.* 1935. Lithograph, printed in color.★★★

Lucebert. Untitled. 1971. Watercolor, pastel, gouache, and pencil on paper.★

Aristide Maillol. *Crouching Woman.* (1930). Bronze.★★

Alfred Manessier. *Living Flame.* (1954). Lithograph, printed in color.★★★

Alfred Manessier. *February in Holland.* 1926. Lithograph, printed in color.★★★

John Marin. *Brooklyn Bridge.* (1913). Etching.★★★

John Marin. *Nassau Street Looking South.* (1924). Etching, printed in black.★★★

John Marin. *Downtown New York.* 1925. Etching.★★★

John Marin. *Brooklyn Bridge on the Bridge, no. 2.* 1944. Etching, printed in black.★★★

Henri-Émile-Benoît Matisse. *Henri Matisse Etching.* (1900–03). Drypoint, printed in black.★

Henri-Émile-Benoît Matisse. *Landscape at Collioure.* (Summer 1905). Oil on canvas.★

Henri-Émile-Benoît Matisse. *Standing Nude, Arms on Head.* (1906, this cast 1951). Bronze.★★

Henri-Émile-Benoît Matisse. *Still Life with Aubergines.* (Summer 1911). Oil on canvas.★★

Michael Mazur. *Study for Closed Ward #8 and #12.* 1962. Brush and pen and brown ink on paper.★

Michael Mazur. *Her Place #2: Study for Closed Ward #8 and #12.* 1962. Brush and pen and brown ink on paper.★

Michael Mazur. *Her Place #1: Study for Closed Ward #8 and #12.* (1962). Charcoal on board.★

Ludwig Meidner. *Curt Valentin*. 1923. Crayon on paper.★★★

Henry Moore. *Mother and Child (No. 1)*. (1956). Bronze.★★

Henry Moore. *Mother and Child (No. 4)*. (1956). Bronze.★★

Giorgio Morandi. *Still Life*. 1927. Etching, printed in black.★★★

Giorgio Morandi. *Still Life*. 1933. Etching, printed in black.★★★

Giorgio Morandi. *Still Life*. 1934. Etching, printed in black.★★★

Giorgio Morandi. *Circular Still Life*. 1942. Etching, printed in black.★★★

Wim Noordhoek. *Abstract Landscape*. 1900. Woodcut, printed in black.★★★

Max Pechstein. *Cabaret*. (1923). Woodcut, printed in black, strong yellow, brown-orange, deep orange, deep red-orange, medium green-blue.★★★

Pablo Picasso. *Meditation (Contemplation)*. (Late 1904). Watercolor and pen and ink on paper.★★

Pablo Picasso. *The Jester*. (1905, this cast 1950s). Bronze.★★

Pablo Picasso. *Bather*. (Winter 1908–09). Oil on canvas.★★

Pablo Picasso. *Nude Woman, Standing*. (1912). Pen and ink with traces of pencil on paper.★★

Pablo Picasso. *The Glass of Absinthe*. (Spring 1914). Painted bronze with perforated absinthe spoon.★

Pablo Picasso. *Head of a Young Man*. (Late) 1915. Oil on panel.★★

Pablo Picasso. *Head of a Woman*. (1916). Engraving with roulette, printed in black.★★★

Pablo Picasso. *The Balcony*. (Aug. 1, 1933). Watercolor and ink on paper.★★

Pablo Picasso. *Faun Unveiling a Woman*. (June 12, 1936). Aquatint.★★

Pablo Picasso. *Woman Dressing Her Hair (Femme assise)*. (June 1940). Oil on canvas.★★

Pablo Picasso. *Faun Flutist and Dancer*. (Oct. 4, 1945). Etching, printed in brown-black.★★★

Pablo Picasso. *Faun and Woman I*. (Oct. 4, 1945). Etching, printed in black.★★★

Pablo Picasso. *Faun and Woman II*. (Oct. 4, 1945). Etching, printed in black-brown.★★★

Pablo Picasso. *Fauness and Woman*. (Oct. 5, 1945). Etching, printed in black.★★★

Pablo Picasso. *Heads of Rams*. (Dec. 7, 1945). Lithograph, printed black.★★★

Pablo Picasso. *The Pipes*. (Aug. 1946). Etching and drypoint on zinc, printed in black.★★★

Pablo Picasso. *Couple*. (Mar. 23, 1947). Lithograph, printed in black (pen and zinc).★★★

Pablo Picasso. *The Sleeping Woman*. (Mar. 23, 1947). Lithograph, printed in black on zinc. ★★★

Pablo Picasso. *David and Bathsheba*. (Mar. 30, 1947). Lithograph, printed in black on zinc.★★★

Pablo Picasso. *Bull's Head, Turned to the Left*. (Nov. 1948). Lithograph, printed in black.★★★

Pablo Picasso. *Bull's Head, Turned to the Right*. (Nov. 1948). Transfer lithograph, printed in black.★★★

Pablo Picasso. *Study of Profiles*. (Dec. 8, 1948). Lithograph, printed in black.★★★

Pablo Picasso. *Lobster and Fish*. (Jan. 7, 1949). Lithograph, printed in black.★★★

Pablo Picasso. *Woman in an Armchair, No. 1*. (Jan. 16, 1949). Lithograph, printed in black on zinc.★★★

Pablo Picasso. *Pregnant Woman*. (1950, this cast 1955). Bronze.★

Pablo Picasso. *Paloma Asleep*. (Dec. 28, 1952). Oil on wood panel.★★

Pablo Picasso. *Portrait of Jacqueline*. (Dec. 4, 1956). Lithograph, printed in black.★★

Pablo Picasso. *Back of a Nude Woman*. (Dec. 22, 1956). Etching, printed in black.★★★

Joseph Piccillo. *Fade Out–D*. Apr. 1972. Carbon pencil on paper.★

Odilon Redon. *Imaginary Figure*. (1875–90). Charcoal and black chalk on cream wove paper.★★

Odilon Redon. *Profile of Light (The Fairy)*. (1882). Charcoal and black chalk on cream wove paper.★★

Odilon Redon. *Spider*. (1887). Lithograph, printed in black.★★★

Odilon Redon. *Ari*. 1898. Lithograph, printed in sanguine.★★★

Odilon Redon. *Green Death*. (c. 1905). Oil on canvas.★★

Marco Richterich. *Holy Family*. (1956). Lithograph, printed in color.★★★

Auguste Rodin. *Hand*. (c. 1884, this cast 1950s?). Bronze.★★

Auguste Rodin. *Crouching Woman*. (1890–91, this cast 1958). Bronze.★★

Auguste Rodin. *Hanako (Japanese Head)*. (c. 1908). Bronze.★★

Auguste Rodin. *Nijinsky*. (c. 1912, this cast 1958). Bronze.★★

Georges-Pierre Seurat. *Covered Cart and a Dog*. (c. 1883). Conte crayon on paper.★★

Pierre Soulages. *Composition V*. (1957). Etching and aquatint, printed in color.★★★

Edward Steichen. *Hanako*. (1908). Gelatin silver print.★★

Théophile Steinlen. Poster: *Compagnie française des chocolats et des thés*. 1874. Lithograph, printed in color.★★★

Théophile Steinlen. Poster: *Le Journal publié la traité des blanches*. 1874. Lithograph, printed in color.★★★

Leslie T. Thornton. *Men Fishing from a Pier*. (1955). Iron wire.★★★

Jacques Villon. *Portrait of the Artist*. 1909. Oil on canvas.★★

Maurice de Vlaminck. *Portait of Solange* (formerly *Portrait of Madeleine* or *Madeleine as a Child*). (1905). Oil on canvas.★★

Lazar Vujaklija. *Composition*. (1955). Lithograph, printed in color.★★★

Hodaka Yoshida. *Woods*. 1955. Woodcut, printed in color.★★★

Hodaka Yoshida. *Teahouse*. 1956. Woodcut, printed in color.★★★

ACKNOWLEDGMENTS

The publication and the exhibition it accompanies reflect the work of many dedicated individuals, both within the Museum staff and outside it. The design of the book has been supervised by Jody Hanson, Director of Graphics, and its production by Amanda Freymann, Production Manager; assistance in each area was provided by Jean Garrett, Designer, and by Cynthia Ehrhardt, Production Assistant. The editing of the texts has been principally in the hands of Mary Christian, who worked with Harriet Schoenholz Bee, Managing Editor, and Christopher Lyon, Editor, to assure the completeness and accuracy of all entries. All of this work took place under the guidance and oversight of Osa Brown, Director of Publications. The photographic component of the catalogue is primarily the fine work of Malcolm Varon, who photographed many of Mrs. Smith's works especially for this publication. Mikki Carpenter, Director of Photographic Services and Permissions, helped make available earlier photographs of other works, and Rona Roob, Museum Archivist, assisted in researching archival photographs of Mrs. Smith.

In preparing entries, Magdalena Dabrowski, Kadee Robbins, and I were aided by Janis Ekdahl, Acting Director of the Library of the Museum, and by Eumie Imm and John Trause, Associate Librarians. Pepe Karmel also generously assisted on special issues regarding the Cubist works by Picasso, and Mary Chan helped prepare catalogue information on the Kandinsky works.

In handling the actual works of art for purposes of photography and exhibition, Pamela Neiterman Graf, Assistant Registrar, has been our valued coordinator and "main mover." Gilbert Robinson, Preparator, has ably and carefully assisted through-out the process. These activities, as well as research needs, have of course demanded—and received, with very good graces—the tireless cooperation of Paula Pelosi, Mrs. Smith's assistant.

I would like also to reserve a special expression of gratitude to Kadee Robbins, who, in addition to authoring many of the entries here, served as an invaluable research assistant and overall coordinator of the project.

Finally, on behalf of the Museum, I would like to extend warmest thanks to Dorothy and Lewis Cullman for their generous support of this publication and exhibition honoring Louise Smith and her collection.

K.V.

TRUSTEES
OF THE MUSEUM OF MODERN ART